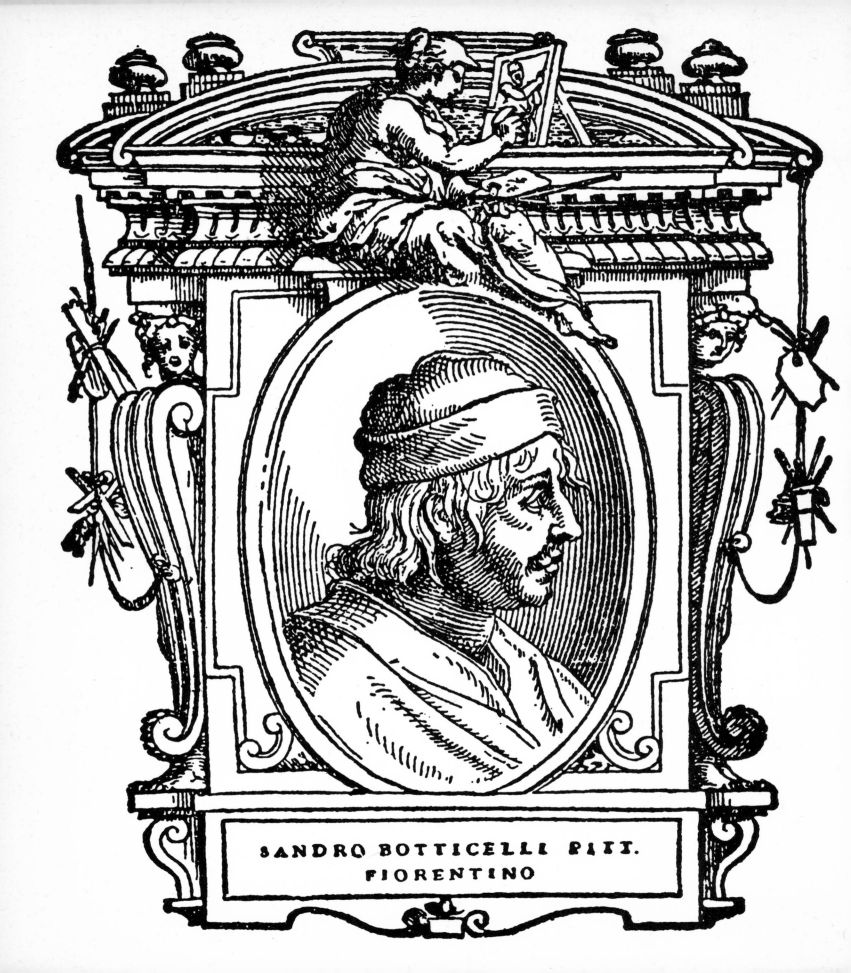

SANDRO BOTTICELLI PITT.
FIORENTINO

Bettina Wadia

Botticelli

The Colour Library of Art
Paul Hamlyn

Acknowledgments

The paintings in this book are reproduced by kind permission of the following collections, galleries and museums to which they belong: Accademia Carrara, Bergamo (Plate 42); Alte Pinakothek, Munich (Plate 46); Dr Martin Bodmer Collection, Cologny/Geneva (Plate 25); British Museum, London (Frontispiece, Figure 5); Capilla de Los Reyes, Granada (Plate 50); Church of Ognissanti, Florence (Plate 17); Crespi Collection, Milan (Plate 14); Fogg Art Museum, Harvard University, Cambridge, Massachusetts, Gift of the Friends of the Fogg Art Museum (Plate 48); Galleria degli Uffizi, Florence (Plates 2, 3, 4, 5, 6, 9, 11, 12, 18, 19, 20, 26, 27, 32, 35, 37, 38, 39, 40, 41); Isabella Stewart Gardner Museum, Boston, Massachusetts (Plates 7, 43); John G. Johnson Collection, Philadelphia (Figure 7); Musée du Louvre, Paris (Plates 1, 29, 30); Bequest of Benjamin Altman 1913, Metropolitan Museum of Art, New York (Plate 47); Musei e Gallerie Pontifici, Città del Vaticano, Sistine Chapel (Plates 21, 22, 23, 24); Museo Nazionale delle Terme, Rome (Figure 6); National Gallery, London (Plates 8, 28, 33, 34, 44, 49); National Gallery of Art, Washington D.C. (Plate 10); Palazzo Pitti, Florence (Plate 16); Poldi-Pezzoli Collection, Milan (Plate 45); Staatliche Museen, Gemäldegalerie, Berlin-Dahlem (Plates 13, 31); Kupferstichkabinett (Figures 2, 3, 4); Victoria and Albert Museum, London (Plate 15, Signature).

The following photographs were supplied by: Accademia Carrara, Bergamo (Plate 42); Joachim Blauel, Munich (Plate 46); British Museum, London (Figures 1, 5); Brompton Studios, London (Signature); Fogg Art Museum, Cambridge, Massachusetts (Plate 48); Giraudon, Paris (Plate 29); Hans Hinz, Basle (Plates 25, 50); Michael Holford, London (Plates 15, 28); Isabella Stewart Gardner Museum, Boston, Massachusetts (Plates 7, 43); John G. Johnson Collection, Philadelphia (Figure 7); Raymond Laniepce, Paris (Plate 1); Metropolitan Museum of Art, New York (Plate 47); Museo Nazionale delle Terme, Rome (Figure 6); National Gallery, London (Plates 8, 33, 34, 44, 49); National Gallery of Art, Washington (Plate 10); Scala, Florence (Plates 2, 3, 4, 5, 6, 9, 11, 12, 14, 16, 17, 18, 19, 20, 21, 22, 23, 24, 26, 27, 32, 35, 36, 37, 38, 40, 41, 45); Service de Documentation, Versailles (Plate 30); Staatliche Museen, Gemäldegalerie, Berlin-Dahlem (Plates 13, 31); Kupferstichkabinett (Figures 2, 3, 4).

Frontispiece: Portrait of Botticelli. British Museum, London. Woodcut in Vasari's *Lives*, 2nd edition 1568, drawn from Filippino Lippi's *Crucifixion of St Peter* in the Brancacci Chapel. Vasari said that Filippino painted Botticelli's portrait when he completed the Brancacci frescoes, so this is probably a fairly reliable likeness of Botticelli at the age of about thirty-eight.

Published by The Hamlyn Publishing Group Limited
Hamlyn House · The Centre · Feltham · Middlesex
© Paul Hamlyn Ltd 1968
Printed in Italy by Officine Grafiche Arnoldo Mondadori, Verona

Contents

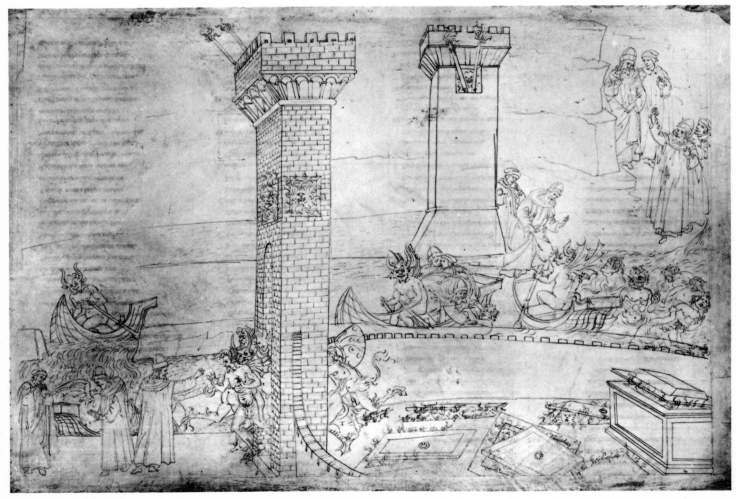

2 Inferno, Canto VIII

Introduction

'In these same days of Lorenzo de' Medici the Magnificent, which was a veritable golden age for men of genius, flourished Alessandro, called Sandro according to our custom, and di Botticello, for reasons which I shall give presently.'

The iron of human life has always created myths of golden ages in the past and hoped for ones in the future. Vasari, writing the opening sentence to his life of Botticelli seventy-six years after the death of Lorenzo de' Medici, was looking back with a certain nostalgia to a time when Florence was the acknowledged cultural centre of Italy, but it was the last phase of a brilliant epoch before the leadership passed to Rome, and Vasari's golden light shone from a setting sun. Lorenzo the Magnificent, who ruled over the city from 1469 to 1492, was the embodiment of its splendour. He was less a Maecenas than a propagandist of her cultural greatness. The commissions he gave to artists were few compared to the patronage of contemporaries like Pope Sixtus IV or Federico da Montefeltro, Duke of Urbino, but he took a vital interest in the arts and his personal friendships with artists and philosophers fostered the intense intellectual life of Florence. He was one of the great collectors of antiquities in Renaissance Italy. The famous Medici collection of classical medallions, cameos, pottery and goldsmiths' work, begun by his grandfather, Cosimo, virtual ruler of Florence from 1434 to 1464, was doubled in his life-time by gifts and purchases from all over Italy. The classical sculptures were placed in the garden of his villa near San Marco and, like the rest of his treasures, Lorenzo allowed artists, whether they were his personal acquaintances or not, to study them freely. His pride in Florence and her fame among the city states is unquestionable: his real contribution to her artistic and intellectual life is doubtful. He was a poet of no mean ability, carefully educated by some of the leading humanists of the time and his reputation as a cultivated man was acknowledged throughout Italy. While Rome epitomised

the splendid maturity of the Renaissance, the Quattrocento in Florence had seen some of its most original artists and thinkers. Botticelli, however, was not one of these. His painting was the fine flower of a private, enclosed world. By its very nature, it could not follow the new realism that was bringing to art an awareness of the deeper emotions and their mysterious communication from one human being to another.

This realism in painting and sculpture, which was a part of Renaissance humanism and the value it placed on the concerns of the individual, was the most important element for the future in Quattrocento art. At the beginning of the century, it was contained by the painting of Masaccio, whose solid figures moving in a three-dimensional space express a natural sensibility quite other than the graceful arabesques decorating the surface of gothic painting. Masaccio's painting is always calm and monumental, but that of Andrea del Castagno in the next generation has an anguished intensity in which statements of the great religious truths offer little peace. Masaccio's *Trinity* in Santa Maria Novella is an immense monolith uniting the Father and the crucified Son. Castagno uses the same iconography in the upper part of his *Trinity* in the Annunziata, but the focal point of the painting is the tormented figure of St Jerome looking up at the cross, and the doctrine is stated in terms of a dialogue between the tortured God and the soul in conflict. The realism of Botticelli's contemporaries, Gozzoli and Ghirlandaio, had none of the heroic qualities of the two earlier painters; it took a naturalistic form and their ostensibly religious paintings are full of closely observed detail from fifteenth century life. Gozzoli's immense procession of the Magi in the Riccardi Palace, commissioned by Cosimo de' Medici, is really a splendid procession of Florentine notabilities and distinguished visitors moving through the Tuscan countryside. Ghirlandaio saw episodes like the Visitation and the

Calling of the Apostles as if they were memorable occasions in the lives of his fellow citizens, whose portraits crowd the biblical scenes he illustrates.

The second stylistic strain in the Quattrocento was International Gothic which was common to all Europe. In Florence its leading representatives were Lorenzo Monaco, a Sienese who settled there, and Gentile da Fabriano, who was working in Florence from 1422 to 1425. It was a precious, courtly art of brilliant colours, gold backgrounds, or a flat drop-cloth of formalised landscape, against which flat figures moved, or posed in exquisite draperies falling in curving rhythms around them. There was no depth, no weight or solidity in this tapestry world. They were among the last representatives of the style but, although the leading artists of Florence were concerned to a greater or lesser degree with problems of space and volume, Gothic painting, like other superseded styles, was absorbed into the new one rather than totally rejected. It remained undeniably a living force to the end of the century and Botticelli owed as much to this lingering medieval spirit as he did to the modern humanism around him.

Alessandro di Mariano Filipepi was born in 1444 or 1445, the son of Mariano di Vanni Filipepi, a tanner. As early as 1472, in the accounts book of the painters' guild, the Compagnia di San Luca, he is called Sandro di Botticello. He was probably brought up by his brother, Antonio, nicknamed Botticello ('little barrel'), which would explain where Botticelli got his familiar name. Antonio was a 'battiloro', or beater of gold leaf, which was used for picture frames and also for the gold backgrounds, aureoles and other decorations that painters still applied to their work. Vasari's assertion that Botticelli became a painter through his brother's connections may well be true; and it is probably also true that he was apprenticed to Fra Filippo Lippi. It was usual for a boy to begin his apprenticeship when he was about

thirteen, sometimes earlier, so Botticelli would not have stayed long in Antonio's workshop. We have no documentary evidence for the beginnings of Botticelli's career, but Lippi's style is the strongest influence on his early paintings and he may well have absorbed it from working under Lippi. This was the emphatically linear style of Florentine painting in which the modelling of the figure remained within a sharply defined contour, like a sculpture standing in bright light, and it was still characteristic of Florentine painting long after Leonardo da Vinci had dissolved the chisel-edge into shadowed imprecision. Other features, more typical of Lippi, which he derived from him, are the shape and angle of the heads (the Madonna in the earliest *Adoration of the Magi* (plate 8) in the National Gallery, London, is an example), the long folds of draperies and the deep, luminous colouring of early work like the *Madonna of the Eucharist* (plate 7). But the warmth and even tenderness in some of his early religious painting are Botticelli's own; the tragedy of the Passion had frequently been given anguished expression in painting and sculpture, and would culminate in Michelangelo's *Pietà*, but these intimate emotions found no place again in art until a century after Botticelli and seldom then. During this brief period at the beginning of his career, he broke through the hieratic impassivity of the immaculate Virgin and the divine Child and saw the centuries old subject as essentially an affectionate relationship between a mother and her baby. Nearly all the paintings, which can be attributed with a greater or lesser degree of certainty to Botticelli, are distinguished by their caressing gestures and the mother's fond concern. It was a brief phase that disappeared before an ethereal abstraction which removed his men and women into an ideal realm shielded from the magnetism and repulsion of human personality. A comparison of the Louvre *Madonna and Child* (plate 1) and the *Madonna of the Rose-bush* (plate 2) with the same subject painted ten to fifteen years later (plates

27, 31, 35) illustrate this change clearly.

Source-hunting can be a fascinating game; it is also one of the more depressing and unreliable activities of scholarship. Any young artist or writer naturally borrows ideas from his predecessors and contemporaries before his individual style has matured: what is far more important and interesting is the value of the work in itself and what he did not borrow. Botticelli's early period, which, allowing for the uncertainties of dating much of his work, lasted to the painting of the *Primavera* (plates 18, 19, 20) about 1478, shows that he was very much alive to the styles and techniques of the Florentine workshops. His debt to Filippo Lippi is the most evident, but the work of the Pollaiuolo brothers, of Verrocchio and Andrea del Castagno, a generation before, all had a certain influence on his work. He never attained the heroic grandeur of Masaccio or gave searing expression to the tragic under-tones of life as Andrea del Castagno did but, on a more superficial plane, his early work shows an awareness of the conflicts and the force of personality that creates them. The *Discovery of the Murder of Holofernes* (plate 6) dramatises violence in pictorial terms as few other paintings did in his time. The horror of the act is conveyed, not so much by the gruesome details of the severed neck and the blood trickling over the sheet, as by the reactions of the soldiers and the force of their varying emotions concentrated on the corpse. The dignified demeanour of the bearded commanders, the histrionic gesture of the man hiding his face in his hands, the self-control of the soldier uncovering the body: calm, sorrow, dismay, curiosity, this acute observation of behaviour and the concentration of the action almost wholly in the foreground so that it presses upon the observer, gives the scene its dramatic immediacy. Apart from the psychological realism, it is a disquieting picture because of the incongruity between this and the sumptuous quality of the painting; the vibrant blues and crimsons, the glinting gold of the armour and the tent fringe like a ceremonial baldaquin, the plastic beauty of the body and the splendid horse, provide a disturb-ing magnificence for murder.

This refinement of the crudeness of life was not peculiar to Botticelli; it was characteristic of the Italian tendency to idealise, which had no serious exception until Caravaggio and the genre painters of the seventeenth century took scenes of low life for their subjects. Botticelli himself seldom showed a real concern for studying from nature; the scene in Holo-fernes' tent was a rare instance and the companion picture, *Judith with the Head of Holofernes* (plate 5) ignores the natural positions of the body as a person walks forward. He frequently painted movement, often vigorous action, especially in his late work, but he used purely conventional methods for suggesting it. The agitated draperies of Judith and her servant and the fluttering napkin round the head were common conventions of the time adopted from Hellenistic and Neo-Attic sculpture (figure 6). The lack of natural observation in the figures, however, is unimportant in this exquisite little painting, an idyll in ochre, blue and green, despite its subject. It was Botticelli's only attempt at a receding landscape view and he may have been inspired by French or Flemish book illuminations. In these, sunlit space and natural detail in country settings, especially for the Calendars in books of hours, was far in advance of other painting. Significantly it is not the Tuscan landscape of Florentine painters of the period, but the fresh green grass and hills of a more northern country. The same type of landscape with turretted, gothic castles, frequently appears in his other paintings, but only as a conventional motif in the far distance.

Much of Botticelli's work at this time was experimental and, like the Judith landscape, never repeated, but the superb nudes of *St Sebastian* (plate 13) and the body of Holofernes were early studies of a subject in which he became one of the century's two greatest painters. The other was Antonio Pol-

laiuolo. Both paintings show the exaggerated bone and muscle structure characteristic of Antonio's work, which Botticelli later smoothed into the more fluid modelling of the Centaur's torso in *Pallas and the Centaur* (plate 26) or Mars in *Venus and Mars* (plate 33). While Pollaiuolo has left us some of the finest Renaissance studies of the male body, generally in vigorous action, Botticelli was famous in his time for his paintings of female nudes. An early sixteenth century chronicle, the *Libro di Antonio Billi*, records that he painted 'many naked women, which were more beautiful than anything else he did' and Vasari, in the first edition of his life of Botticelli, makes a similar statement. If there were indeed so many, few have survived; the rest are workshop copies, but the *Primavera* and *Birth of Venus* remain among those rare moments in art when the beauty of the human body has been completely fused with an intellectual concept as distinct from an allegorical representation of an idea. The other artist of the Renaissance who successfully achieved this was Michelangelo, who was more profoundly imbued than Botticelli with Neoplatonism.

Botticelli's connection with the Pollaiuolo brothers at this time was not limited to Antonio's stylistic influence; in 1470, he painted the *Fortitude* (plate 3), one of seven allegorical figures of the virtues, which the powerful guild of the Arte della Mercanzia had commissioned from Piero Pollaiuolo, but the head of the guild, Tommaso Soderini, succeeded in getting the commission for two of the paintings transferred to Botticelli. In the end, he only did the *Fortitude*, probably because Piero protested and other Florentine artists took a poor view of the guild's broken contract. All seven paintings are now hanging together in the Uffizi and no one can fail to be struck with the immeasurable superiority of Botticelli's painting over that of Piero. The figure certainly does not suggest strength and courage; Fortitude dandles her mace in the same unwarriorlike way as St Michael fingers his sword in the *Altarpiece of San Barnaba* (plate 36); but, unlike the other virtues, she is a majestic presence, solid and firmly seated on the elaborate throne. The gentle, subtly modelled head is one of the most vital that he ever painted, partly because the eyes are wide open, so unlike the unseeing, or half-closed eyes of his later work.

The commissioning of the *Fortitude* through Soderini's intervention was a landmark in Botticelli's career. Soderini was a close friend of Lorenzo de' Medici and the initiative for the interference on Botticelli's behalf, which he must have foreseen would cause trouble, is more likely to have come from Lorenzo. If this is so, the incident marked the beginning of Botticelli's long association with the Medici, which lasted for nearly thirty years. He did a certain amount of work for Lorenzo, or his brother, Giuliano: a bed-tester painted with the figure of Fortune, the standard embroidered with the figure of Pallas for Giuliano, on the occasion of the famous tournament in 1475, a fresco of the hanged Pazzi conspirators in 1478, and some murals in the Medici villa at Spedaletto. His most important patron, however, was Lorenzo di Pierfrancesco de' Medici, cousin of Lorenzo the Magnificent. Lorenzo di Pierfrancesco was a generous art patron and commissioned some of Botticelli's finest work: the *Primavera* (plates 18, 19, 20), the *Birth of Venus* (plate 32), *Pallas and the Centaur* (plate 26), and the illustrations for Dante's *Divine Comedy*.

We have no record of when Botticelli opened his own workshop with assistants, but it was probably as early as 1470; Filippino Lippi, son of Filippo Lippi, was working as his apprentice in 1472 and is likely to have joined him in 1470, when he left Spoleto for Florence the year after his father's death. Until nearly the end of the century, it was one of the leading workshops of Florence and the most popular supplier of madonnas for private and public patrons, but this devo-

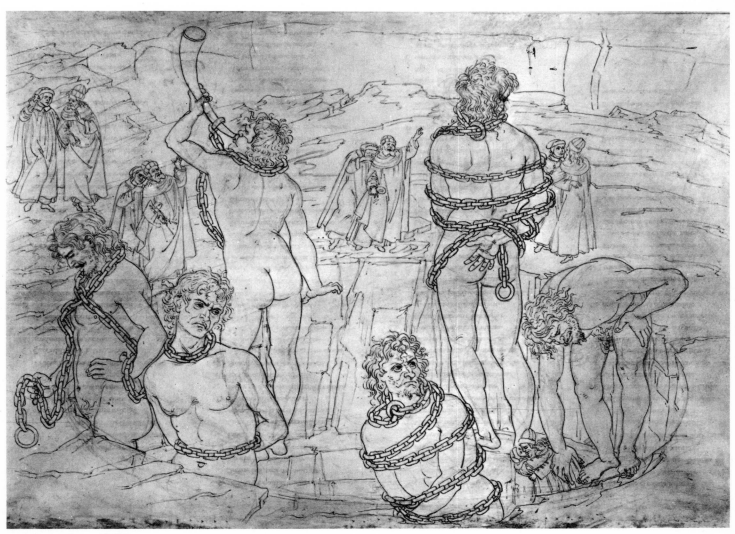

3 Inferno, Canto XXXI

tional painting alone would not have given Botticelli the special place he enjoys in the history of Quattrocento art as the great humanist painter of the Early Renaissance. He was the one painter chosen from the constellation of artists in Florence at the time to interpret the ideas of the Neoplatonists from Marsilio Ficino's Academy at Montevecchio.

This was not an institution in the sense that we understand the word 'academy', nor as the Italians of the sixteenth and seventeenth centuries understood it, when professional bodies for training artists or defending their interests sprang up all over Italy. It was a small group of men, with various occupations and intellectual interests, who gathered at Ficino's villa to discuss philosophy, poetry, art, morality, classical and oriental philology, and to enjoy each other's company. Although the subjects of their debates were varied, they were dominated by the Neoplatonic philosophy of Ficino and Pico della Mirandola. Two philosophers, Cristoforo Landino, the foremost Latin scholar of the day, and Angelo Poliziano, a poet, were the leading spirits of the circle. The Academy had its beginnings under the rule of Cosimo de' Medici whose interest in Greek thought, especially Platonism, was as great as in classical antiquities. He encouraged Greek scholars to settle in Florence and was instrumental in having the distinguished scholar, Argyropoulos, appointed to the university as Reader in Greek. Marsilio Ficino was the son of Cosimo's doctor. He paid for his classical studies and asked him to translate Plato's dialogues into Latin, gave him the villa at Montevecchio near his own at Careggi, and spent as much of his busy life as he could spare in the company of Ficino and his friends. Cristoforo Landino and Ficino were two of Lorenzo's tutors, so he had every encouragement to share his grandfather's literary and philosophical interests, and he was a devoted member of Ficino's Academy.

In 1492, a German humanist, Martin Uranius, wrote asking him for detailed information about the Academy. Ficino's answer included a list of its forty members: philosophers, merchants, poets, philologists, theologians, diplomats, but—and this perhaps is the rather surprising fact, in view of the importance of Neoplatonism for Botticelli—not one artist. Although several of the members were generous art patrons, the Academy was primarily a literary and intellectual society, yet its tangent could touch the circle of a painter's genius into the purest expression of Neoplatonic humanism.

Marsilio Ficino's system was a development of the Neoplatonism of Plotinus within the framework of Christian doctrine. Astrology and classical mythology added an often extremely tortuous adjunct to the main structure of his thought. His essential teaching was that the soul should withdraw into itself from the external world and, from contemplation of the divine image in itself, rise through the ascending scale of intelligible things and transcendent ideas, to attain the vision of God Himself. In the hierarchy of the cosmos, reaching from God down to the material world, the love and knowledge of the human soul established a strongly knit unity: a concept that gave a special dignity to man. On the social plane the virtue of *humanitas*, which comprised Ciceronian urbanity and culture as well as the love and respect of men for each other, established the solidarity of mankind. The mythological figure that represented *humanitas* was Venus, the Venus of Botticelli's *Primavera* (plate 18), the *Birth of Venus* (plate 32), *Venus and Mars* (plate 33) and perhaps also the Villa Lemmi frescoes (plates 29, 30). In a letter which Ficino wrote to Lorenzo di Pierfrancesco de' Medici, about 1477-78 when Lorenzo was only a boy of fourteen or fifteen, he described all the virtues of Venus, who should guide his footsteps through life: Love, Charity, Dignity, Magnanimity, Liberality, Magnificence, Comeliness, Modesty, Charm, Splendour. In spite of the stress laid on spiritual contemplation, the Neoplatonic ideal of the good life also required worldly qualities.

The tantalising question of how familiar Botticelli was with

Neoplatonic ideas can never be satisfactorily answered. They provide the most convincing interpretation of *Pallas and the Centaur* and the Venus pictures, especially the *Primavera*, which was probably based on a 'programme' drawn up by Ficino and his friends. Beyond this, the only statement that can be made with any certainty is that the mood and style of this group of paintings are wholly in keeping with the spirit of the Neoplatonic Academy, and that Botticelli would not have chosen mythological subjects if the men connected with it or influenced by it, had not commissioned them. But for this his output would have been limited to a few portraits and the religious paintings commissioned by private patrons or religious institutions.

But however fascinating the Neoplatonic element in these paintings may be, they have a universal appeal far beyond their philosophical content and to us now it adds little or nothing to our appreciation. Botticelli's contemporaries, Lorenzo de' Medici, Pierfrancesco, the philosophers and poets who gathered at Ficino's villa, would have associated them naturally, as we do not, with the ideas they discussed so passionately; but they, like us, would surely have been moved, not by their intellectual content, but by their ideal of human beauty and its refinement of the ancient myths, the birth of love from the sea and the return of spring to the earth. The romantic savagery of Holofernes' murder, the blue and green morning of Judith's return have become etherealised, yet the spell of these paintings lies more in what Botticelli retained than in what he discarded; they are a fusion of the old and the new, the culmination of the first phase of the Renaissance before Leonardo, Michelangelo and Raphael gave the second a grandeur and profundity unknown to earlier creators.

It has often been observed that Botticelli's Venuses bear a strong likeness to his Madonnas and that the Christian overtones are particularly strong in the Venus of the *Primavera*, who is making the same gesture with her right hand as the Virgin of Baldovinetti's *Annunciation* in the Uffizi. This fusion of the spiritual and secular, Christianity and pagan mythology, was characteristic of Florentine Neoplatonism but it was also inherent in medieval courtly love poetry in which the lady was treated like a divinity by her poet or knight. The *Primavera* was the earliest of the Neoplatonic paintings and it is also the most medieval in spirit. The orange grove and the figures lined in front of it have the flatness of a tapestry; the flower-strewn ground is like the gardens of *La Vie Seigneuriale* and the *Dame à la Licorne*, or the exquisitely decorated flower borders of illuminated manuscripts but, like the mythological figures, Botticelli has transmuted them by a spring enchantment all his own. The motif of the dancing Graces originated in Greek and Roman literature and was copied repeatedly in Renaissance sculpture and medallions, but none of them has the soaring, undulating line of his goddesses, or the gossamer transparency of the draperies. Like the other creations of the classical mind, they are transformed by the imagination of a painter who was more familiar with medieval art and romance than with the classical learning of Ficino and his friends. Venus Anadyomene and the figures of the Villa Lemmi frescoes are again more gothic than Greek and it is significant that *Pallas and the Centaur*, which is the nearest in spirit to classical art of all the mythological paintings, is also the coldest and most austere.

The decorative element, which is so pronounced in the mythological paintings, was not a superficial feature of his style but an expression of his whole attitude to painting. The range of his portraits, imaginary and real, from the individual faces of the men in Holofernes' tent to the late portraits, for example that of Lorenzo Lorenzano (figure 7), shows that he could paint a study of personality as strikingly as any other artist. The atmospheric changes of tone over a distant view in the Judith landscape (plate 5) and the architectural backgrounds of the late work (plate 44), all

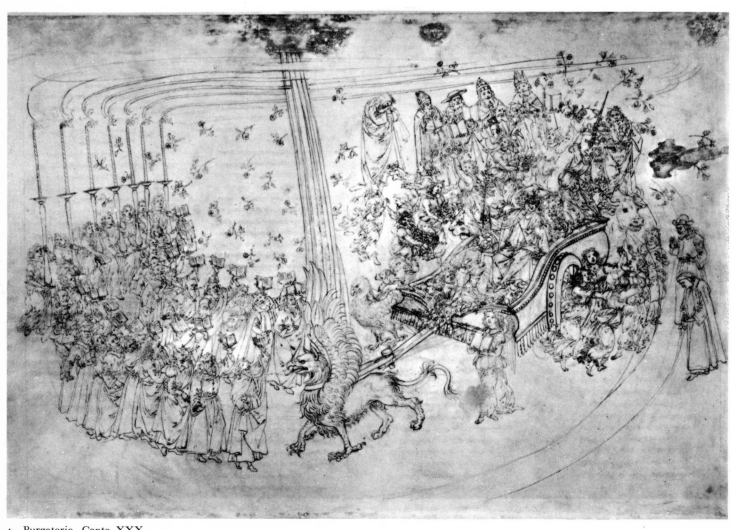

4　Purgatorio, Canto XXX

have a sense of swinging space. With such realism at his command, Botticelli preferred a decorative and artificial composition to the illusion of reality in a large number of his works. The device of crowding the figures right up to the front of the picture was at this time highly original although it became a commonplace some decades later. Botticelli employed this mannerism with dramatic force in *The Discovery of the Murder of Holofernes* but by the same method produced a quite different effect in the mythological paintings which is purely decorative. The row of figures in the *Primavera* across the flat screen of trees is processional, in a slight right to left movement set up by the gesturing hands and the direction of the bodies. The composition of *Venus and Mars* is completely static and the compact, symmetrical shape made by the reclining couple is like adjacent triangles of mosaic, firmly set into the oblong picture area by the horizontal lance; there is little to suggest two people at rest in its artificial arrangement. There is both movement and rest in the *Birth of Venus* but, although the winds and Hora are in vigorous action, they make an arch, which is completely stabilised by the figure of Venus down the centre and again there is a formal pattern, this time like the stone tracery of a window overlooking the sea. The word 'decorative' has a slightly pejorative meaning applied to art, often wrongly so; in this painting it is the means of lifting the myth of Venus Anadyomene into the realm of imagination, where the truth it contains cannot be apprehended before rejecting the truth of sense perception. This glaucous ocean world, sky blue-green, sea olive-green by the foreshore, paling in the middle distance before it darkens again towards the horizon, like the receding line of the dark green land, is tipped with the gold of an alchemist sun, touching the foreground, gilding the ridges of the shell, outlining the leaves and the rose-stems, the feathers and hair of the winds, and burnishing the tree-trunks with its precious rays. Only the violet

at Hora's feet and the cornflowers on her dress belong to another world.

Botticelli's unreality goes much deeper than these surface effects and is the essence of the spell he exerts, as few other painters can, over the thousands of people who trudge dutifully through the Uffizi on their summer holidays. If the nude figure of St Sebastian is not anatomically sound, it at least gives an illusion of naturalness. Countless figures in the Vatican frescoes and in the several versions of the *Adoration of the Magi* leave an equally realistic impression, but he deliberately distorted the human figure, sometimes to give more forceful expression to an idea, generally for the sake of creating a more beautiful shape. The Virgin's figure in the Uffizi *Annunciation* (plate 38) is a moving example of expressive distortion, as she twists from the lectern, swaying away and reaching towards the acceptable and dread annunciation. The figures of the three Graces in the *Primavera* stand poised in a perfection that no natural women could ever attain. These are only two instances where it would be absurd to apply naturalistic criteria. Botticelli's creatures, whether mythical, supernatural or earthly men and women, exist in a world suspended beyond functional cause and effect; their exquisite hands seldom grasp anything; the Madonnas hardly ever hold their babies, the hands of his warriors and saints are long, marmoreal arabesques over their weapons and staves.

At the centre of Botticelli's painting there is a stillness, devoid even of potential movement. The problem of how to suggest figures in movement was not successfully solved until the beginning of the sixteenth century and the discovery of its technical mastery culminated in the restlessness of the Baroque, when a seated sculpture of Bernini was a storm-centre of sweeping draperies and gestures, and architecture undulated in perpetual motion. In early painting, although the figures may be standing or sitting, there is nearly always

some suggestion that the immobility is temporary, but the figures that focus the main attention in Botticelli's painting exist in the stillness of eternity: Venus and Mars are dissociated in their physical perfection from the mischievous fauns playing round them. Venus, born out of the sea, is so entirely statuesque that she arrests the violent motion converging on her and turns the wind-blown scene into a static composition. Botticelli's angels are as spirited as the fauns, but the Madonnas they encircle are abstracted and remote. The Villa Lemmi frescoes, where the figures are either moving or sitting naturally, are the exceptions among his major paintings. This is not to say that he did not paint action—the four Vatican frescoes (plates 21-24) and the late narrative paintings are full of it—but the illustration of action is not the same as painting movement convincingly. Botticelli rarely succeeded in doing so. The three consecutive scenes in the *Destruction of Korah and His Associates* (plate 23) are all dramatic episodes with fairly energetic actions, but the men performing them can hardly be described as moving in a life-like manner; rather they pose in histrionic attitudes. His walking figures are always static, in spite of various conventional indications like fluttering draperies and one foot placed prominently forward. In the early work, they tend to lean back, a stately but impossible posture; in the middle period of the Vatican frescoes, they straighten up; and in the late *St Zenobius* panels (plate 44) the axis of the body pitches forward in a decidedly unbalanced effect.

The whole problem of showing figures in movement is bound up with the way they are placed in space and their relations to each other. It was his weakness and his strength that he never successfully solved either aspect of the problem. He was intensely aware of the solitary figure, which partly, or perhaps completely, explains his inability to relate it to others. The great creations of Botticelli's imagination remain alone among those who surround them, indifferent and unaware of their presence: Flora, Venus Anadyomene, the Madonnas with saints or angels, Pallas distractedly twisting her fingers into the Centaur's hair. Only the Venus, lying beside Mars, is an exception and, in one of those unaccountable quirks of creative genius, the painter of the lone, withdrawn being has also conceived one of the most moving paintings of the couple. It is a subject painted many times since Botticelli, especially in the seventeenth and eighteenth centuries as the celebration of a marriage or engagement, but no artist, until Picasso in some of his Blue Period works and the drawings of the Vollard Suite, has invested it with the same poignancy. Intimacy also demands isolation. During the intervening centuries, the relationship of the couple was treated as a social event, but both Botticelli and Picasso have seen it as the ideal union between a man and a woman whose attraction for each other is physical and emotional with no utilitarian or ritual associations.

It has already been pointed out that Botticelli could give an impression of space when he felt the painting needed it. His skill in perspective was in fact praised by Luca Pacioli in his *Summa de Arithmetica et Geometria*, published in 1494 in Venice, but he could not relate figures in movement to the landscape or architecture around them. This failure is striking in two of the Vatican frescoes, the *Destruction of Korah and His Associates* (plate 23) and *Purification of the Leper and the Temptation of Christ* (plate 22), which he painted at the height of his powers. In the first, the three episodes are all grouped side by side in the foreground, there is no attempt to connect the figures and they are all overwhelmed by the architectural mass of the triumphal arch, although it is placed in the middle distance. The groups are better placed to fill the picture area in the second fresco, the Hospital of Santo Spirito is less awkwardly prominent than the triumphal arch, but the fresco as a whole still falls into disparate groups and even single figures, which is not altogether the

fault of the multiple subject imposed on Botticelli. The three men by the bench on the extreme left, the woman carrying the bundle of faggots, the child struggling with the grapes and the serpent on the right, and the multifarious activities going on behind the altar, are all interesting pieces of independent illustration, but they bear no dramatic or psychological relation to the central episode or to the small scenes from the life of Christ around it.

The group subject in which he showed an increasing mastery in arranging a crowd for the greatest dramatic effect was the Adoration of the Magi. It was the last of the major Christian subjects to appear in art but, once it had been 'discovered' in the early fourteenth century, it was popular among painters, including manuscript illuminators, because it offered almost unlimited opportunities for painting splendid retinues and exotic costumes. Botticelli did not take advantage of them in the four complete versions we still possess from his brush, which is strange considering his luminous colours and profuse use of gold in several paintings of the Madonna and Child. The two earliest are in the National Gallery, London. The tondo (plate 8) is an unhappy experiment; the Virgin and the group around her are considerably diminished by the towering arch behind them, the attendants around her show a total unconcern for the exceptional event they are witnessing, the detached semi-circle in the foreground breaks the composition uncomfortably and Botticelli's endeavour to give the men a casual air has produced some unnatural posturing. The third version, the famous 'Medici' *Adoration* (plate 9), painted about five or six years later, is altogether a more satisfactory group composition; the figures, arranged in two arcs, are linked by the second king kneeling in the centre of the picture and providing a firm base for the main group of Mary, Joseph and the first king. In spite of Vasari's statements, we are not sure which of the Medici or how many of them were portrayed, but it is obvious that the

work, commissioned by Guaspare di Zanobi del Lama, a friend of the Medici, does contain a number of portraits. It was common practice at the time to use paintings of religious scenes as a portrait gallery of contemporaries. Ghirlandaio took it to extreme lengths and Gozzoli's procession of the Magi in the Medici Palace is a splendid example of this particular subject used as a celebration of the family and Florentine notabilities. But it turned a religious painting into a ceremonial occasion and Botticelli's picture, where the Virgin and Child are relegated to the background, is no exception. The last complete version (plate 10) was painted when he was at the height of his powers and it is one of the most profoundly spiritual *Adoration of the Magi* ever painted. It is not made the excuse for portraiture—the clothes and trappings of the horses are strikingly simple compared with the regal pomp of Gothic or contemporary artists, the attendants not engaged in the act of worship are kept at a distance from the circle in front of the Child, no irrelevant details distract attention from its solemn homage. The arrangement of the worshippers in the foreground stresses this aspect of the scene and the gap immediately in front of the observer not only gives an uninterrupted view of the Virgin and Child, it also has the psychological effect of drawing him into the circle. The unfinished version (plate 11) gives a far more complex and dramatic rendering, but the placing of the assembled figures is basically the same as in the tondo thirty years before; only the crowd round the Child, simplified and stable in the Washington picture, is now swept in a centripetal movement towards the Holy Family, by the same wind that blows through so many of his late paintings.

Most of us are incorrigibly romantic. We prefer the tale of Giuliano de' Medici and Simonetta Vespucci to contemplating the formal beauty of Botticelli's Venus and Flora. The popular version of his final phase makes a good story

too: the great painter, shattered by Savonarola's moral fulminations, turns from his exquisite Madonnas and lovely mythological figures to sterner stuff; his worldly patrons desert him and he dies a poor and broken man. The facts, however, point to a less flushed account.

The Simonetta legend revolves round the mythological paintings of his middle period. Flora in the *Primavera*, Venus in the *Birth of Venus* and *Venus and Mars* are all portraits of Simonetta Vespucci with whom Giuliano de' Medici, the brother of Lorenzo, was passionately in love. Botticelli further celebrated their affair by portraying Giuliano as Mercury in the *Primavera* and as the slumbering Mars. The facts are these. Simonetta was the wife of Marco Vespucci, who was a member of one of the powerful Florentine families. On the occasion of a celebrated tournament in 1475 she was Giuliano's chosen lady. Florence was famous for these festivals which were conducted strictly according to all the magnificent ritual of medieval pageantry. Giuliano won the prize, as was right and proper, and the tournament was celebrated by two of Florence's leading poets, Poliziano and Pulci. Simonetta died soon afterwards, on 26 April 1476, and Giuliano was assassinated in the Pazzi conspiracy exactly two years later. None of Botticelli's three paintings had been begun by the date of Simonetta's death. A date about 1478 is generally agreed for the *Primavera* and about 1485/86 for the other two. More significant still is the fact that both the *Primavera* and the *Birth of Venus* were painted for Lorenzo di Pierfrancesco, who belonged to the younger branch of the Medici family, and, as has already been pointed out, Botticelli's connections were with them rather than with the elder branch. No contemporary ever suggested a model for his mythological figures and it is surely remarkable that his nineteenth century critics were the first to detect a resemblance between them and a lady of whom we possess no portrait (the inscription, 'Simonetta Januensis Vespuccia', beneath Piero di Cosimo's portrait of a young woman in the Musée Condé, Chantilly, was added by a later hand; apart from this she bears no resemblance to Botticelli's women).

The effect of Savonarola on Botticelli deserves more serious consideration, but there is no evidence that he was a *piagnone* ('a tearful person', the derisive name given to Savonarola's followers, presumably because of their behaviour while listening to his preaching).

Savonarola first preached publicly during Advent of 1482 in two small Florentine churches, but even by 1484, when he delivered the Lenten sermons at San Lorenzo, his weak delivery and Ferrarese accent created an unfortunate impression. His Dominican superiors posted him to other towns during the following six years and he did not return to Florence until 1490. In the meantime, he had become a powerful public speaker and his apocalyptic sermons, directed against abuses in the Church, which were flagrant, and against Florentine morals, which were probably no worse than those of sinful humanity at any period, were devastating. Savonarola was given to seeing visions and his prophecies of disaster added to his popular appeal. The extraordinary influence of this Dominican friar over the daily life and politics of the city dates from Lent 1491, when he preached for the first time to the vast audiences that could be packed into the cathedral. Lorenzo de' Medici died in April 1492, and Piero, his well-intentioned but inexperienced young son was elected to the offices held by his father. When he was unable to prevent the invasion of Charles VIII of France in 1494, he fled from Florence and in the more broadly based government, which was then set up, Savonarola was a powerful force. In 1498, the bitter opposition he had roused provoked his condemnation by the ecclesiastical authorities and he was hanged and burnt at the stake.

The sincerity of his reforming zeal is unquestionable. The humanists' admiration for pagan culture was trounced and

the artists also came in for their full share of condemnation: instead of being painted with heavenly lineaments, Magdalen and St John were the portraits of well known Florentines; the Virgin Mary was a poor villager, who was never dressed in the gorgeous raiment the painters gave her; paintings of nudes and courtesans were dangerously seductive. The Burning of Vanities on Shrove Tuesday, 1497, included these and the reason that so few of Botticelli's 'many, most beautiful naked women' have survived may be because they were sacrificed to Savonarola's puritan zeal on this occasion.

In 1494, Botticelli's younger brother, Simone, returned from Naples and came to live with him. Simone's chronicle is extant, and, although he himself was a *piagnone*, there is no suggestion in it that Botticelli shared his sympathies. In the entry under 2 November 1499 he records that, as they chatted by the fire in the evening, Sandro told him about the visit he had received that day from Doffo Spini, one of Savonarola's bitterest enemies who had taken a leading part in examining the friar. When Sandro asked him for the truth about the sins that led to his condemnation, Spini confided: 'Sandro, must I tell you the truth? We never found any, neither mortal nor even venial.' If Simone's account of his answer is suspect, because of his devotion to Savonarola, it is still unlikely that Spini would have paid a social call on a *piagnone* and we know from another source that Botticelli was friendly with Spini. It is even more significant that Simone was one of the three hundred and thirty-six citizens who signed the petition against the Pope's excommunication of Savonarola in June 1497, while Botticelli did not. Moreover when Simone fled for safety to Bologna after Savonarola's arrest, Botticelli remained in the city with the rest of the family.

The change in manner that is supposed to have come over his paintings as the result of a spiritual conversion was, in fact, part of a gradual development. This is noticeable as early as 1485, the date of the *Madonna with St John the Baptist and St John*

the Evangelist (plate 31) well before Savonarola's return in 1490 and the Lenten sermons of 1491, which were the real beginning of his ascendancy. There is a greater depth and seriousness in several of the late paintings, but this again can be explained by the natural development of the artist as he grew older. The only specifically Savonarolesque subject is the *Mystic Crucifixion* (plate 48) in which the imagery can be traced to one of the preacher's visions. The *Mystic Nativity* (plate 49) has not the same obvious connection. The theme of the Kingdom of God and the new dispensation on earth inaugurated by the birth of Christ is fundamental to Christian thought and the apocalyptic terms of the inscription in Greek (see note on plate 49) do not necessarily reflect the influence of Savonarola's sermons. There is no doubt that he was an extraordinary personality, but his visionary sermons and prophecies of disaster were characteristic phenomena of the times. It was a disturbed period; supernatural signs and astrological predictions are a feature of contemporary chronicles such as that of Luca Landucci. They were familiar manifestations during this waning of the Middle Ages which was also the dawn of a new age.

The detachment of Botticelli's figures in the paintings of the middle period can only be described as a psychic withdrawal. A comparison between two tondos, the *Madonna of the Magnificat* (plate 27) with the *Madonna of the Pomegranate* (plate 35) separated by about five years, is revealing. The first group is securely contained within the encircling frame, the three outer angels enclosing the two others, the Virgin and Child, in a completely self-absorbed little world. Although the Virgin has lost the warmth and tenderness of the early mothers and has nothing of the vitality of the angels as she dips her pen distractedly into the ink-pot, she is attentive to what is happening and the child is firmly seated on her lap. The mood of the *Madonna of the Pomegranate* is quite different. The introspective absorption has disappeared; the

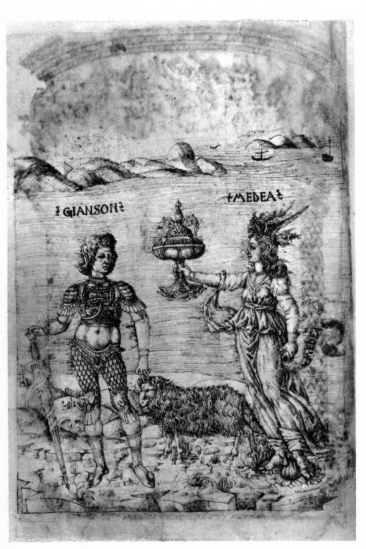

5 Jason and Medea

angels have opened out into a screen behind the Virgin, she herself has become the abstracted mother, with the characteristic inclination of her head, hardly supporting the Child, unaware of Him as her unseeing eyes are directed out of the picture.

The magnificent figure of *St Augustine* (plate 17) in the Ognissanti church, documented in 1480, is a tremendous embodiment of intellectual and spiritual power, which Botticelli never achieved again although he often repeated the same type in the doctors of the Church. Placed beside the *Madonna with St John the Baptist and St John the Evangelist* (plate 31), which can be dated 1485 from recorded payments made to Botticelli, the change in sensibility is striking. The Madonna is the most moving image he ever painted of her, there is none of St Augustine's militant strength in either of the saints and the painting is the work of a man deeply affected by the pathos of the human condition. The mannerism apparent in the unusually elongated body of the Madonna and, to a certain extent, in the Baptist's *contrapposto* (the shoulders twisting unnaturally in a different direction from the rest of the body) is accentuated in the *Altarpiece of San Barnaba* (plate 36) especially in the weary anguish of the Baptist and the effeminate St Michael.

The spiritual lassitude disappeared in the painting done in the last fifteen years of his working life, as far as we are able to date its productions, but the mannerism increased until the figures in the late narrative paintings seem tormented by a wind-blown frenzy. Drama verges on hysteria in the episodes of the murder of Virginius' daughter from the *Story of Virginia* (plate 42) and the resurrection of the noblewoman's son from the *Miracles of St Zenobius* (plate 44). The frantic gestures, the swirling, billowing garments and the seething knots of people seem all the more unbridled against the majestic marble architecture or the sunlit streets, which are deserted except for the people caught up in the drama.

The distortion cannot be explained by the violence of the scene, because two of the personifications in *Calumny* (plate 41), Deceit who is putting roses in Calumny's hair and Suspicion whispering into the king's ear, are both engaged in banal actions, but both are contorted and almost overbalancing. Yet, as additions to the moral hurly-burly of deception and injustice, they are artistically justified and the statuesque calm of Truth is rendered all the more impressive by comparison.

The late Botticelli is an enigmatic artist. Savonarola has generally been offered as an explanation by critics, struck by the contrast between his mature work and the last paintings, but the contrast, as we have seen, is fallacious. There was a gradual development of form and expression, not a sudden change and Botticelli was not a *piagnone*. The great Neoplatonic paintings have given an exceptional character to the middle period, but their subjects were suggested to him by an exceptional group of men. It is wholly improbable, since he did not belong to the Academy, that he chose them himself. Apart from a few portraits, the rest of the work was religious painting commissioned by private patrons or ecclesiastical institutions, a normal situation for an artist at that time. Even if we accept the theory of Savonarola's influence, his late paintings have not the uniformly sombre or spiritually uneasy atmosphere that its defenders would claim for it. *Calumny* as well as the narrative pictures of Virginia, Lucretia and St Zenobius all show a delighted and thoroughly worldly interest in designing imaginary architecture, with a wealth of decorative detail. The hard, bright light casts few shadows over them; the streets of St Zenobius' town are unreal in their porcelain clarity and the smooth, sunlit sea through the arches of the king's palace is like the dream of an eternal summer beyond the conflicts of this earth. It is incongruous, too, that he should have placed the most tragic episode of the Passion, *The Agony in the Garden*

(plate 50), in a country setting of shrubs and farmyard fencing, such as he had not painted since the idyllic scene of Judith's return. The story certainly requires it but, perhaps because it was night when Christ went to the Mount of Olives, other painters have not given it a rural background.

With these less serious preoccupations and the increasing mannerism of his style, there went a deeper feeling for the tragedy of the human condition. His only painting of the Crucifixion and the Agony in the Garden are late works, and the two *Pietà* (plates 45, 46) belong to the same period. The almost claustrophobic crowding into the immediate foreground of a picture had been a peculiar feature of Botticelli's painting from the beginning, especially in the tondos of the Madonna and Child surrounded by angels. Here in the Milan *Pietà*, the heaped, packed composition gives the subject an extraordinary emotional intensity. This is strengthened by the simple structural lines: the dome-shaped mass through which the vertical axis drops from the crown of thorns, down the arms of St John and the Virgin; the strong, horizontal line, formed by the heads of the Virgin and the women on either side, which swings down through the body of Christ and along to the Magdalen's head to form a second horizontal line, parallel with the base of the dome. How much the drama of this painting owes to the composition can be appreciated by comparing it with the Munich version, where the group has broken apart and the emotional concentration is consequently weakened. Another work associated to a certain extent in subject matter and in dramatic concentration with the Passion paintings is the *Last Communion of St. Jerome* (plate 47). The time when an artist was free to choose his subjects had not yet arrived, so it is probable that every one of Botticelli's paintings was commissioned. But obviously a good deal of freedom of interpretation was allowed. It is worth noting how in several pictures Botticelli placed a pomegranate, one of the symbols of the Passion, in

the hands of the Christ Child.

Since the religious paintings and also the late portraits of *Lorenzo Lorenzano* (figure 7) and *Michele Marullo* show an increase of power rather than a falling off, it at first seems difficult to understand why Botticelli lacked employment at the beginning of the sixteenth century. On 23 September 1502, the agent of Isabella d'Este, Duchess of Ferrara, wrote a letter to her to say that he could not get Perugino, as she wished, to complete the paintings for her study which had been left unfinished by Mantegna. Perugino was in Siena, and Filippino Lippi was too busy, but 'another one, Alessandro Botechiella, has been much praised to me as an excellent painter and as a man who works willingly, and he is not busy as the others'. Vasari, though an unreliable guide to the artist's life, has an interesting comment to make, in the Preface to Part III of his *Lives*, on the swing of taste away from Botticelli's generation to the new artists led by Leonardo da Vinci. Among their superior technical accomplishments, he mentions the naturalness and grace of their figures that came from studying the newly discovered classical sculpture. This removed the 'dry, severe, incisive style' characteristic of a number of painters among whom he lists Botticelli. This was the linear style of the Florentine Quattrocento which no painter had used with more exquisite refinement than Botticelli. Berenson called him 'the supreme master of the single line'. It was his unique means of expression; there is little contrast of light and shadow in his work, with the result that one of the principal means of expression in the younger painters' work was absent from his own. Leonardo, in fact, was only eight years younger, but he was a man of the new age. Much that lent power to his painting had been discovered when he was a boy or before he was born: Pollaiuolo shared his scientific attitude when he dissected corpses to study anatomy; Piero della Francesca's space had a mathematical as well as an imaginative validity; Donatello's sculp-

ture and Castagno's frescoes had introduced a new emotional range into art. It was not the fact either that all this was united in one extraordinary genius that distinguished Leonardo's work from the Quattrocento painters, but that it was the expression of a wholly different sensibility. The dramatic event of the Nativity or the Last Supper ceases to be a set piece commissioned and painted a thousand times: it is an impassioned study of the tensions attracting and repelling the people involved. Botticelli could never have penetrated this chiaroscuro of human personality.

The difference between them can be appreciated by comparing some of their paintings: the emotional tensions of Leonardo's unfinished sketch for the *Adoration of the Magi*, 1481, with Botticelli's (plate 10) of about the same year, a deeply religious but ceremonial conception; the *Virgin of the Rocks*, 1483-1506, with Botticelli's *Madonna of the Pomegranate*, (plate 35) about 1487. Leonardo was working on the *Last Supper* in 1497, about the time of Botticelli's Munich and Milan *Pietà*. Leonardo painted the startled reactions to the prophecy of betrayal and Botticelli portrayed the numbing grief after the event: the contrast between the individuality of the apostles and the universalised emotions of the *Pietà* represents a fundamental difference of approach between the two artists. From 1501 to 1505, both Leonardo and Michelangelo were working in Florence, and the High Renaissance had begun.

No further explanation is needed for the neglect Botticelli suffered in the latter part of his life. Vasari's description of a feckless character, spending all the money from the Vatican frescoes before he returned to Florence, wasting time over the Dante illustrations instead of doing more lucrative work, finally refusing to work at all after becoming a *piagnone*, only managing to live with the kindly support of Lorenzo de' Medici, garbles history as well as Botticelli's biography, but it may have had some grain of truth in it. Several testi-

monies of his high reputation in the city have survived, yet he seems to have remained a comparatively poor man. It was not until 1494 that he possessed any landed property, the first sign of substance at that time; and the tax return for 1495 shows that his means were modest.

Opinions about his temperament, after a lapse of nearly five centuries and with no reliable information available, are merely speculative. His work, which we do possess, is a surer guide to the real character of his art. The realism of Florentine Quattrocento art had little appeal for him. The proportions of his female nudes are Gothic and his male nudes were only superficially influenced by an artist like Pollaiuolo who studied anatomy scientifically. The portraits, throughout his career, from frank young men painted in his early years (plates 12, 28) to the humanists at the end of it, are individual personalities: the one aspect of his painting where he was concerned to reproduce outward appearance. Except as an interpreter of the Neoplatonists' ideas over a period lasting about ten years from the *Primavera* to *Pallas and the Centaur*, classical culture meant little to him as an artist and, even in the mythological paintings, the influence is literary rather than artistic. Roman architecture provides decorative motifs in some work and Roman sarcophagus sculpture may have been the model for the Centaur and for *Venus and Mars*, but these are rare echoes of the excitement caused by the revaluation of Greek and Roman art. The ultimate source of his fluttering draperies was the Hellenistic relief sculpture of Maenads, but he did not necessarily borrow directly from these. They were a common feature in popular Florentine art, and can be seen on innumerable *cassoni* (chests decorated with paintings of medieval romances and classical stories) and in engravings, particularly the series by Maso Finiguerra in c. 1460 (figure 5). His conventional landscape backgrounds with rivers, hills and trees were the stock in trade, too, of the *cassoni* painters and engravers.

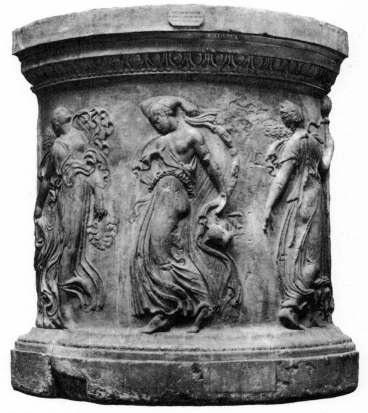

6 Neo-Attic Well-Head

Botticelli's own contribution to the minor arts was probably a constant feature of his career. It has not been proved that he actually supplied drawings for engravings, although there are a number so strongly marked by his style that it is quite possible. Vasari refers to a number of his embroideries and his invention of a process for making standards 'so that the colours do not run, and show on both sides'. He designed Giuliano de' Medici's standard for the tournament in 1475, which has not survived, but the embroidery on the hood of a cope, preserved in the Poldi-Pezzoli Museum, Milan, is probably by him. The intarsias in the Ducal Palace at Urbino are so Botticellian in manner that it would be difficult to attribute them to anyone else, but again we have no actual proof that they are his. We are on sure ground with his painting of panels for bench-backs: *Fortitude*, the *Story of Virginia*, the *Tragedy of Lucretia* and the four panels of the *Miracles of St Zenobius* were all painted for this kind of interior decoration.

His outstanding contribution to the minor arts was the illustration of Dante's *Divine Comedy*. The episode involves the same strands of popular art, Neoplatonic personalities and Florentine politics that were so often woven into Botticelli's career. It was the Academy that firmly established Dante's reputation with their publications and enthusiastic admiration. Cristoforo Landino, one of its members, published an edition of the *Divine Comedy* on 30 August 1481. Places for the illustrations were left throughout, but the most complete edition only contains nineteen engravings, stuck in afterwards, which are evidently engraved from Botticelli's rough sketches but are not by him. He was engaged on the Vatican frescoes at the time and probably left these drawings incomplete when he was summoned to Rome. The illustrations, reproduced here, are from the great set of drawings commissioned by Lorenzo di Pierfrancesco de' Medici probably in 1482 on Botticelli's return from Rome. One illustration to each canto was the original plan, but the project was not completed. Lorenzo had to flee from Florence in the latter part of 1497 or early 1498, accused of plotting against the city's enemies, and with the departure of his old patron, Botticelli probably stopped work.

The narrative details in the illustrations to the *Inferno* (figures 2, 3) and *Purgatorio* (figure 4) show that he knew the text well and his brother, Simone, evidently shared his interest; he owned the manuscript of an anonymous commentary, which is in the Biblioteca Nazionale at Florence. The illustrations have a strongly individual flavour as if Botticelli were drawing them to please himself rather than his humanist patron. Except for the drawing of the giants in *Inferno XXXI*, there is hardly a trace of influence of classical art; even the gods and Titans of *Purgatorio XII* are medieval rather than Greek. Fittingly, he created a hell of medieval towers, boats and devils, and Beatrice makes her entrance in the *Purgatorio* with Florentine pageantry. But historical or literary accuracy would never have been seriously entertained by an artist who could paint the Arch of Constantine as a setting for the story of Moses and Korah, nor even by his carefully educated patron. As this 'supreme master of the single line' lavished some of his finest draughtsmanship on this last tribute to the medieval world, he was surely happy, and those other creatures of his imagination, Flora, Venus and the three Graces, born over the same years, live with Beatrice in an eternal spring, where the centuries fall into oblivion and the Vale of Tempe becomes one with a medieval empyrean in the mind of a Florentine painter.

Biographical Outline

1434 Cosimo de' Medici recalled from exile and becomes virtual ruler of Florence.

1444/45 Birth of Alessandro di Mariano Filipepi.

1458, Feb 18 Declaration to the Registry by his father that Botticelli is 13 years old and is either 'at school' or 'is setting jewels'. The handwriting is blurred at this point and can be interpreted either way.

1464 Death of Cosimo de' Medici and his son, Piero, succeeds him.

1469 Death of Piero de' Medici. Lorenzo, his son, called Il Magnifico, is invited by the citizens to assume his father's duties at the head of the government.

1472 Botticelli's name appears in the Libro Rosso, the accounts book, of the Compagnia di San Luca. Filippino Lippi is also recorded as his apprentice.

1474 Botticelli goes to Pisa in January. Paints a fresco (destroyed in 1583) in the Chapel of the Incoronata in the cathedral as a demonstration of his ability to paint the frescoes in the cemetery. Commission given to Benozzo Gozzoli instead.

1475 Makes a standard with the figure of Pallas for Giuliano de' Medici's tournament.

1478 Attempt by the Pazzi to murder Lorenzo and Giuliano in the cathedral. Giuliano is killed.
Botticelli paints a fresco of the conspirators hanged after the failure of the conspiracy (destroyed in 1494).

1481 Declaration to the Registry indicates that three apprentices are working in his shop.

 Leaves for Rome, begins work on Sistine Chapel frescoes.

1482 Returns to Florence in the spring or summer.

1490 Savonarola returns to Florence.

1491 Preaches in the cathedral for the first time.
Botticelli is a member of a commission formed to judge a competition for a design for the cathedral façade.
Commissioned as one of the artists to decorate the vault of the San Zenobio chapel in the cathedral with mosaics. Work on the chapel was never finished and there is no record of Botticelli's particular contribution.

1492 Death of Lorenzo de' Medici. His son, Piero, succeeds him.

1494 Charles VIII invades Italy. Piero de' Medici surrenders four Florentine fortresses in attempt to negotiate peace. He is driven out of Florence. City ruled by a Grand Council.
Botticelli acquires house and land outside Porta San Frediano, near Bellosguardo.

1498 Death of Savonarola.

1504 Operai (administrative body of the cathedral) assembles the leading architects and artists to decide where to place Michelangelo's *David*.
Botticelli agrees with Cosimo Rosselli that it should be placed on the corner of the cathedral steps.

1510, May 17 Botticelli buried in the cemetery of the Ognissanti church.

1512 Louis XII driven out of Italy by the Holy League. Return of the Medici to Florence.

Comments on Botticelli

Sandro di Botticelli is an excellent painter of panel paintings and frescoes; they are painted in a vigorous style, with the soundest judgment and perfect proportion.

> From a report by an agent to Lodovico Sforza, Duke of Milan, c. 1485

If a painter is not equally attached to all the elements of painting he is not versatile; if, for instance, he does not care for landscape and thinks it is only worth a cursory, simple investigation, like our Botticelli when he said that studying landscape was a waste of time, because you could see a fine landscape in the stain made on a wall by just throwing a sponge against it soaked in different colours.

> Leonardo da Vinci *Treatise on Painting* published from his notes 1651

The emaciation of long prayer, asceticism and mortification. Bodies, whose physical outline, attenuated, rarified, refined so to speak by spiritual aspirations, is dry and angular. Flesh like flowers flowering in the shade, whose shadows have the transparency of amber. And with these, their attitudes, clothed in the fluttering draperies with broken folds of Albert Dürer, are dreamy, thoughtful, abstracted from this world.

> Edmond and Jules Goncourt *L'Italie d'hier: notes de voyages, 1855-56*

So just what Dante scorns as unworthy alike of heaven and hell, Botticelli accepts, that middle world in which men take no side in great conflicts, and decide no great causes, and make no great refusals. He thus sets for himself the limits within which art, undisturbed by any moral ambition, does its most sincere and surest work. His interest is neither in the untempered goodness of Angelico's saints, nor the untempered evil of Orcagna's *Inferno*; but with men and women, in their mixed and uncertain condition, always attractive, clothed sometimes by passion with a character of loveliness and energy, but saddened perpetually by the shadow upon them of the great things from which they shrink. His morality is all sympathy; and it is this sympathy, conveying into his work somewhat more than is usual of the true complexion of humanity, which makes him, visionary as he is, so forcible a realist.

> Walter Pater *The Renaissance* 1870

. . . he was the only painter of Italy who thoroughly felt and understood Dante; and the only one who also understood the thoughts of Heathens and Christians equally, and could in a measure paint both Aphrodite and the Madonna. So that he is on the whole, the most universal of painters; and, take him all in all, the greatest Florentine workman.

> John Ruskin *Fors Clavigera* 1872

Ah! Botticelli, Botticelli! the elegance and grace of suffering passion, the profound feeling of sadness in voluptuousness! all our modern soul apprehended and transposed, with the most disquieting enchantment that ever came from an artist's creation.

> Narcisse, a character in *Rome* by Emile Zola 1896

Well! imagine an art made up entirely of these quintessences of movement-values, and you will have something that holds the same relation to representation that music holds to speech — and this art exists, and is called linear decoration. In this art of arts Sandro Botticelli may have had rivals in Japan and elsewhere in the East, but in Europe never. . . The representative element was for him a mere libretto: he was happiest when his subject lent itself to translation into what may be called a linear symphony. And to this symphony everything was made to yield; tactile values

were translated into values of movement, and, for the same reason — to prevent the drawing of the eye inward, to permit it to devote itself to the rhythm of the line — the backgrounds were either entirely suppressed or kept as simple as possible. Colour also, with almost a contempt for its representative function, Botticelli entirely subordinated to his linear scheme, compelling it to draw attention to the line, rather than, as is usual, away from it.

Bernard Berenson
Florentine Painters of the Renaissance 1896

Of all his generation in Florence Botticelli was the one artist in whom the Greek world of myth and legend stirred a chord akin to the devotional. The very incompleteness of his knowledge saved him from a fond fidelity to external aspects; but in any case we may believe he would have been saved from that by the innate poetic sincerity of his nature. The forms in which he imagined the divinities of Greece were not the braced yet rounded proportions of antique sculpture, with their balance and serenity, but the forms he found among the youth of his own Tuscany, long-limbed, large-jointed, a little lean, with a beauty of character rather than of type, and faces in which sweetness mingles with a kind of trouble of unrealized emotion.

Laurence Binyon *The Art of Botticelli* 1913

SELECTED BOOK LIST

Alessandro Filipepi. Herbert Horne. George Bell 1908.
A monument of scholarly documentation. Some attributions have dated, but it is still the best critical biography.

Botticelli. G. C. Argan. Skira 1957.
General critical account with strong emphasis on Neoplatonism.

Botticelli. André Chastel. George Rainbird 1958.
Brief critical essay. An excellent introduction to the paintings.

Early Florentine Designers and Engravers. J. G. Phillips. Harvard 1955.
Attribution of particular engravings to Botticelli is unconvincing, but his strong influence on contemporary engravers is impressively illustrated.

Sandro Botticelli. Y. Yashiro. Medici Society 1925.
Botticelli through Japanese eyes. Generally perceptive, sometimes wayward, always refreshing.

The Golden Age of the Renaissance: Italy 1460-1500. André Chastel. Thames and Hudson 1965.
Good account of cultural and historical background to Botticelli's life and work.

Notes on the illustrations

Figure 2 *Inferno, Canto VIII*. Drawing. 18½ × 12⅝ in. (47 × 32 cm.). Kupferstichkabinett, Staatliche Museen, Berlin-Dahlem.
Dante and Virgil arrive at the River Styx and are rowed across to the tower guarding the City of Dis, where the evil spirits refuse them entrance. The wholly medieval conception of Hell, the towers, the boats and devils, as well as the old-fashioned practice of representing several phases of a narrative in one composition, are a notable illustration of how naturally a medieval way of thinking came to Botticelli.

Figure 3 *Inferno, Canto XXXI*. Drawing. 18½ × 12⅝ in. (47 × 32 cm.). Kupferstichkabinett, Staatliche Museen, Berlin-Dahlem.
Dante and Virgil arrive in the Ninth Circle where the giants, defeated by Jupiter, tower up into the Eighth Circle. The Pollaiuolesque nudes seem curiously modern among the medieval conceptions of these illustrations to *The Divine Comedy*.

Figure 4 *Purgatorio, Canto XXX*. Drawing. 18½ × 12⅝ in. (47 × 32 cm.). Kupferstichkabinett, Staatliche Museen, Berlin-Dahlem.
The meeting of Dante and Beatrice. The car of the Church Triumphant, accompanied by the Theological and Cardinal Virtues dancing in circles, meet the twenty-four elders representing the books of the Old Testament. Dante with Statius stands on the opposite side of the stream to Beatrice.

Figure 5 *Jason and Medea*. 1435. British Museum, London. An engraving from a long series by Tommaso Finiguerra which forms a sort of 'Universal History in Pictures' before the birth of Christ. Medea's draperies and sandals are typical of the kind worn by several of Botticelli's figures.

Figure 6 *Neo-Attic Well-Head*. 1st century copy of 5th century B.C. original. Museo Nazionale delle Terme, Rome.
Cassoni decorators and engravers like Finiguerra copied the classical sculptures of maenads and the convention of fluttering draperies to suggest movement. There is every likelihood that Botticelli, among other Quattrocento painters, was drawing on the popular art around him when he painted similar figures, rather than imitating classical sculptors directly.

Figure 7 *Portrait of Lorenzo Lorenzano*. c. 1490. Panel. 19¼ × 14½ in. (49 × 37 cm). John G. Johnson Collection of Art, Philadelphia.
Lorenzano was a scholar. The date of his birth is unknown. He taught dialectic at Pisa University in 1479, then physics in 1482 and medicine in 1487. He was friendly with Pico della Mirandola and also Savonarola, whom Pico admired. He committed suicide in 1502.

THE COLOUR PLATES

Plate 1 *Madonna and Child*. c. 1468-70. Panel. 28⅜ × 20½ in. (72 × 52 cm.). Musée du Louvre, Paris.
One of Botticelli's earliest paintings of the subject. The affectionate relationship between the mother and baby is characteristic of these, but the resemblance to Lippo Lippi's style and Madonna type are so strong that it was attributed to him until comparatively recently.

Plate 2 *Madonna of the Rose Bush*. c. 1469-70. Panel. 49 × 25¼ in. (124 × 64 cm.). Galleria degli Uffizi, Florence.
Probably a later work than the previous painting. The gentle modelling of the face soon disappeared before a more strictly linear style, but the long, graceful hands remained one of the hallmarks of Botticelli's painting. The pomegranate is his favourite motif in Madonna and Child pictures and one of the symbols of the Passion.

Plate 3 *Fortitude*. 1470. Panel. 65¾ × 34 in. (167 × 87 cm.). Galleria degli Uffizi, Florence.
Botticelli's earliest documented work. Commissioned by the Arte della Mercanzia (introduction page 10). This figure and the six Virtues by Piero Pollaiuolo bear a strong resemblance to a series of contemporary engravings of sibyls and prophets. According to a long tradition going back to the early years of Christianity, it was considered that the pagan sibyls had prophesied the Messiah's coming. They often figure in mystery plays and pageants. The elaborate throne of Fortitude and the armour are typical of the engraved allegories.

Plate 4 *Madonna with St Cosmas, St Damian and Other Saints*. c. 1470-72. Panel 67 × 76½ in. (170 × 194 cm.). Galleria degli Uffizi, Florence.
Sometimes called the *Altarpiece of the Convertite*. A number of sources mention that Botticelli painted an altarpiece for the church of the Augustinian nuns of St Elizabeth of the Converted, but it has not been satisfactorily identified with this or any other of his works. Magdalen, on the left, with her diaphanous veil, is the most Botticellian figure of the group. The light from a source on the left, and the shadows and highlights on the robes unite the whole painting and are an example of a naturalism that he abandoned later.

Plate 5 *Judith with the Head of Holofernes*. c. 1470-72. Panel. 12½ × 9 in. (31 × 25 cm.). Galleria degli Uffizi, Florence.
The colouring, the dawn freshness and the tonal gradations in the sky and receding landscape are unique in Botticelli's work. They may well have been inspired by landscapes in illuminated books. The line of ramparts is a common feature in them, but it is also exactly like the old walls of Florence which the visitor, standing on the Piazzale Michelangelo and looking over to the Belvedere, can see today. Did Botticelli, too, have these in mind rather than a Flemish or French painting? The sunlight on the women's clothes is an exquisite piece of naturalistic painting, but the figures themselves are an illustration of a realistic impression of motion made by totally unrealistic methods; the servant, for instance, has only one leg.

Plate 6 *Discovery of the Murder of Holofernes*. c. 1470-72. Panel. 12½ × 9 in. (31 × 25 cm.). Galleria degli Uffizi, Florence.
The companion picture to *Judith with the Head of Holofernes* (introduction page 9). The depth and brilliance of the colour belong to a different tonal range from the other painting, but they are again unequalled in his other work.

Plate 7 *Madonna of the Eucharist*. c. 1472. Panel. 33 × 24¾ in. (84 × 65 cm.). Isabella Stewart Gardner Museum, Boston.
The title comes from the wheat-ears and grapes, symbols

of the Eucharistic bread and wine. Symbols of the Christian faith and life of Christ, particularly the Passion, were common in paintings of the Madonna and Child at any period, but they are seldom introduced so naturally as here.

Plate 8 *Adoration of the Magi*. c. 1472-76. Panel. Diameter 51½ in. (131.5 cm.). National Gallery, London.
The tondo is the *Epiphany* that Vasari said was painted for the Pucci family. The composition is the least formal of all Botticelli's paintings of the subject and it has all kinds of picturesque details, like the monkeys, the deer chasing through the wood and the inquisitive dwarf, that were banished from later versions. The sharply plunging viewpoint was an old device used so that the faces in a group could be seen (see introduction page 17 for further comments on this and later versions).

Plate 9 *Adoration of the Magi*. c. 1476-77. Panel. 43½ × 52¾ in. (111 × 134 cm.). Galleria degli Uffizi, Florence.
Commissioned by Guaspare di Zanobi del Lama for the altar at the right of the main door in Santa Maria Novella. It is the most famous, if not the best of Botticelli's five versions, because of the portrait game that has been played round it ever since Vasari declared that the first king was a portrait of Cosimo de' Medici, the second of Giuliano (assassinated in the Pazzi conspiracy) and the third (added as an afterthought in the second edition of the *Lives* 1568) was of Cosimo's son, Giovanni. The identifications have varied in number and complexity ever since. Lami was a friend of the Medici and it is quite likely that their portraits were included in the painting, but the tradition was already seventy years old when Vasari wrote the first edition (1550) of the *Lives* and the identifications even then must have been untrustworthy. The man standing on the extreme right is supposed to be a self-portrait of Botticelli.

Plate 10 *Adoration of the Magi*. c. 1481-82. Panel. 28 × 41 in. (71 × 104 cm.). National Gallery of Art, Washington D.C.
Undoubtedly the finest of the five versions, it was probably painted while Botticelli was in Rome or soon after his return to Florence.

Plate 11 *Adoration of the Magi*. c. 1500. Panel. 42¼ × 68⅛ in. (107.5 × 173 cm.). Galleria degli Uffizi, Florence.
Unfinished. It was drawn in bistre on a ground by Botticelli and partly coloured, probably in the seventeenth century. Apart from the Vatican frescoes, this was his most ambitious crowd scene. In no other did he manage to produce this impression of surging, excited movement towards the single point of interest. The massive rock formations are a curious departure from the usual classical ruins that provide a setting for Nativity paintings.

Plate 12 *Portrait of a Man with a Medal*. c. 1473-74. Panel. 23 × 17¼ in. (57.5 × 44 cm.). Galleria degli Uffizi, Florence.
At this time, the easel portrait had hardly developed as a separate branch of painting. The narrative fresco was the most usual place for portraits and Ghirlandaio took the practice to extremes, while Botticelli was the least affected by the fashion. His contribution to the art of the easel portrait here was important. It was one of the first to show the sitter's hands and focus attention on them with the medal. This is in gilded stucco and may be an actual cast of the medal struck after the death of Cosimo de' Medici. It bears his head and the inscription: *Magnus. Cosmus. Medices. P.P.P.* Attempts to identify the sitter have been unsuccessful.

Plate 13 *St Sebastian*. c. 1474. Panel. 76¾ × 29½ in. (195 × 75 cm.). Staatliche Museen, Gemäldegalerie, Berlin-Dahlem.
The debt to the Pollaiuolo brothers' muscular painting of

anatomy is strong and it has been suggested that Botticelli based his figure on their *Martyrdom of St Sebastian* in the National Gallery, London. If there is such a connection between the two paintings, the documentary evidence indicates that the debt was the other way round, as Botticelli's was probably the earlier work.

Plate 14 *Portrait of Giuliano de' Medici*. c. 1475. Panel. 21½ × 14¼ in. (54.5 × 36.5 cm.). Crespi Collection, Milan.
Giuliano was the brother of Lorenzo the Magnificent and a close companion in all his activities, until he was assassinated in the cathedral by the Pazzi conspirators in 1478. Its chief interest is as a historical document, although the date and authenticity from Botticelli's hand have been questioned. As portrait painting it has not the originality of the *Man with a Medal*.

Plate 15 *Portrait of Smeralda Bandinelli* (?). c. 1471-78. Panel. 25½ × 16⅛ in. (66 × 41 cm.). Victoria & Albert Museum, London.
The identification of the sitter is questionable, because the inscription could not have been painted until 1530, the year when Smeralda's husband took the name of Bandinelli. Whoever the sitter, Botticelli has given her a gracious, dignified presence and it is indeed one of the earliest formal portraits of a woman that communicates an individual personality in spite of the formality.

Plate 16 *Portrait of a Young Woman*. c. 1478. Panel. 24 × 15¾ in. (61 × 40 cm.). Palazzo Pitti, Florence.
Botticelli's most austere portrait. He has returned to the simple profile of the earliest easel portraits. Only the velvet dress relieves the subdued colour, and the exceptionally incisive lines of the face and neck are accentuated by the hard line of the cord; not even the pendant shows to add a touch of frivolity. His style became noticeably more linear in this period and the slight modelling gives the figure an unpleasantly flat effect, emphasised by the rectangular lines behind. This distressingly plain young woman has been claimed to be Simonetta Vespucci (introduction page 17). Vasari wrote: 'There are two female heads in profile by his hand in the wardrobe of Duke Cosimo, one of whom is said to be the mistress of Giuliano de' Medici... the other... Lorenzo's wife.' Herbert Horne made the most sensible suggestion that it was Fioretta Gorini, Giuliano's mistress and the mother of Giulio de' Medici, who became Pope Clement VII.

Plate 17 *St Augustine*. c. 1480. Fresco. 60 × 44⅛ in. (152 × 112 cm.). Church of the Ognissanti, Florence.
St Augustine, like *Fortitude* painted ten years before, belongs to a traditional type, which Botticelli used whenever he painted the doctors of the Church, but the tradition alone could not have created this tremendously powerful figure. Its monumentality and the spiritual and intellectual intensity of the facial expression anticipate some of Bernini's sculptures. Botticelli had moved away from his earlier naturalism by this time, but he sends the play of light over the draperies, the folds of the table-cloth, the silver book-marker over the lectern and the open book propped against the wall, with a scintillating virtuosity he had not attempted before. The careful detail of a thinker's study, like the geometric drawings in the open book and the paper curling out of the drawer, does not obtrude on the attention. The subject did not offer the imaginative conceptions of the mythological pictures, but undoubtedly it stands beside them as Botticelli's finest work.

Plates 18, 19, 20 *Primavera* and details. c. 1478. Panel. 70 × 123⅝ in. (203 × 314 cm). Galleria degli Uffizi, Florence.

Vasari described this as 'a Venus in company with the Graces and flowers, denoting Spring'. This simple interpretation is the best, perhaps the only one, for its appreciation of a painting unaffected by some of the more tortuous explanations that have been lavished upon it for more than half a century. However, there is no doubt that the original intention of Botticelli and his patrons was to illustrate Neoplatonic ideas. It was painted for Lorenzo di Pierfrancesco de' Medici. E.H. Gombrich associates the occasion with a letter written by Marsilio Ficino about 1477/78 in which he urges Botticelli to take Venus for his guide. She represents *humanitas*, the quality that embraces Love, Charity, Dignity, Magnanimity, Liberality, Magnificence, Comeliness, Modesty, Charm, Splendour. It was a common practice during the Renaissance to present a painter with an elaborate description and the Neoplatonists may have based theirs on the ballet of Venus, the Graces and the Seasons that Lucius watched in the *Golden Ass* of Apuleius. The painting is crowded with literary allusions from other classical sources as well. The group on the right illustrates the tale from Ovid's *Fasti*, where Zephyr pursues the nymph, Chloris, and as he touches her, she is transformed into Flora, the herald of spring. Mercury was the leader of the Graces and for the Neoplatonists represented the intellect that explores secret knowledge; his action here, reaching with his caduceus or wand into wisps of cloud, symbolises this. Plate 19 shows the Graces, and plate 20 Zephyr, Chloris and Flora.

Plate 21 *Scenes from the Life of Moses*. 1481-82. Fresco. 11 ft. 5 in. × 18 ft. 3¾ in. (348 × 558 cm.). Sistine Chapel, Vatican.
The episodes are taken from Exodus II, III and XIII. Lower right: Moses kills the Egyptian who had struck a Hebrew; above, a woman helps away the wounded man under a porch; beyond the porch and up the fresco, Moses flees to Madian because he realises his murder of the Egyptian is discovered. Centre: Moses drives away the shepherds who have prevented Jethro's daughters from watering their flocks and then draws water from the well himself. Upper part: God appears to Moses out of the burning bush and Moses takes off his shoes at His command. Left: Moses leads the Hebrews out of Egypt.

Plate 22 *Purification of the Leper and the Temptation of Christ*. 1481-82. Fresco. 11 ft. 4 in. × 5 ft. 1 in. (345.5 × 555 cm.). Sistine Chapel, Vatican.
The three small groups in the upper part illustrate the three temptations of Christ in the desert. On the extreme left, He returns to Jerusalem accompanied by angels. The central episode is ambiguous. It either refers to the purification of the leper whom Christ cured immediately after his return (Matthew VIII); or to the complicated purification rites for a leper described in Leviticus XIV. The building in the centre is the Hospital of Santo Spirito, built by Sixtus IV who commissioned the frescoes. He was a Franciscan and, as there is a connection between Christ's miracle, the work of the hospital and St Francis' care of the sick, the first explanation seems the more likely. The themes of the previous fresco and this are parallel: the first illustrates Moses' preparation for his mission; the temptations in the desert were a similar preparation for the public life of Christ, which began and was symbolised by the cleansing of the leper.

Plates 23, 24 *Destruction of Korah and his Associates*, and detail. 1481-82. Fresco. 11 ft. 5 in. × 18 ft. 8½ in. (348.5 × 570 cm.). Sistine Chapel, Vatican.
The rebellion of Korah with two hundred and fifty of the Hebrews against the authority of Moses and Aaron is recounted in Numbers XVI. The three episodes in the fresco should be read from right to left: 1. The beginning of the

rebellion. The attempt to stone Moses is a vivid detail that does not appear in the Old Testament. 2. This also is an apocryphal elaboration. The smoke from the rebels' censers miraculously turns against them and the authority of Moses and Aaron is justified. 3. The rebels are swallowed up into the earth.

The painting is the symbolic counterpart to Perugino's *Delivery of the Keys* on the opposite wall of the chapel and is intended as a warning to rebels against the Pope's authority. To the right of the Arch of Constantine stand the ruins of the Septizonium of Severus, which were taken down in 1585 by Sixtus V who used the columns in building the Vatican. As it was situated under the Palatine hill near the Circus Maximus, it could not have been seen by an observer who also had a full view of the arch. Botticelli was painting a topographical fantasy in bringing them together like this and it is an interesting early example of the *capriccio*.

Plate 24 is a detail showing the beginning of the rebellion. At the time of writing this fresco has been cleaned and the colours are therefore much brighter than those in the other two frescoes.

Plate 25 *Portrait of Dante*. c. 1480-85. Canvas. 21¼ × 18½ in. (54.5 × 47.5 cm.). Collection, Dr Martin Bodmer, Cologny/Geneva.
The members of Ficino's Neoplatonic Academy had an immense admiration for Dante and they did much to establish his reputation as a great poet. The attribution of the portrait to Botticelli is not certain, but his connection with the Academy, the commission to illustrate *The Divine Comedy* and his personal interest in the poet would make it not unlikely. The austere features were by this time traditional.

Plate 26 *Pallas and the Centaur*. c. 1482. Canvas. 81½ × 58¼ in. (207 × 148 cm.). Galleria degli Uffizi, Florence.

Various political and moral interpretations have been suggested for this allegory. The comment by Marsilio Ficino quoted by E. H. Gombrich is the most convincing: 'Wisdom prescribes to philosophers... whenever they desire to grasp a beloved thing they should rather aim at the top, at the heads of things than at the feet below.' One of the recurrent themes of the Neoplatonic thought was the distinction between man, brute and God, and their relationship. Man aspires to God away from his animal desires, which explains the yearning look on the Centaur's face. The three interlocking rings with pointed diamonds, decorating the dress of Pallas, was one of the devices of the Medici family. It was painted for Lorenzo di Pierfrancesco de' Medici.

Plate 27 *Madonna of the Magnificat*. c. 1482. Panel. Diameter 46½ in. (118 cm.). Galleria degli Uffizi, Florence.
The double circling movement of the arch, the arms of the angels, holding up the crown, and continued down along the Virgin's left arm encloses the group in the tondo shape. The arrangement of its serene figures is exceptionally skilful to avoid a feeling of overcrowding. Restorers in the past have repainted much of it, but the preciousness of the diaphanous veils, the refinement of the gold rays and crown, and the gold tinged hair has not been coarsened.

Plate 28 *Portrait of a Young Man*. c. 1482. Panel. 14¾ × 11 in. (37.5 × 28 cm.). National Gallery, London.
The direct, compelling look is a hallmark of Botticelli's portraits of young men, whether they were Florentine like this one, or celestial imps attending the Madonna.

Plate 29 *Villa Lemmi Fresco: Young Man Presented to the Seven Liberal Arts*. c. 1483. Fresco. 89⅜ × 81⅞ in. (227 × 269 cm.). Musée du Louvre, Paris.
The two frescoes reproduced here used to decorate the

Villa Lemmi in what is now a suburb of Florence. They were discovered under whitewash and sold to the Louvre in 1882. A third was too damaged to be worth removing. The most likely interpretation of this scene is that it belongs to the Neoplatonic group of paintings. Venus-Humanitas (introduction page 12) is presenting the young man to the allegorical figures of the Trivium and Quadrivium, presided over by Rhetoric. The Albizi family crest was added at a later date to this fresco and it was originally thought that the two together celebrated the marriage of Lorenzo Tornabuoni with Giovanna degli Albizi, who was identified with the young woman in the next fresco (plate 30). However, Giovanna's authentic portrait is known from a medal by Niccolò Fiorentino, which is also identical with a figure in Ghirlandaio's *Visitation* in Santa Maria Novella. The young woman is obviously not Giovanna herself, but resembles one of the girls following her in the *Visitation*. The chief interest of the painting is the homeliness of the Arts. Rhetoric has an almost sibylline grandeur, but the others in the learned assembly look like a collection of village gossips.

Plate 30 *Villa Lemmi Fresco: Young Woman and Four Mythological Figures.* c. 1483. Fresco. 84 × 111¾ in. (212 × 284 cm.). Musée du Louvre, Paris.
See note on Plate 29. Venus (with the sandals) leads the Graces with an offering for the young woman.

Plate 31 *Madonna with St John the Baptist and St John the Evangelist.* 1485. Panel. 73 × 70⅞ in. (185 × 180 cm.). Staatliche Museen, Gemäldegalerie, Berlin-Dahlem.
Originally painted for the Bardi Chapel in the church of Santo Spirito with a frame carved by the architect, Giuliano da Sangallo, which unfortunately has been lost. The symbolism of the olive, palm and cedar leaves comes from the words of Wisdom, *Ecclesiasticus* XXIV, 17-19. Vasari wrote

that they were painted 'with whole-hearted delight', but the leafy screen adds to the inexplicable melancholy of the group. The elongated figure of the Virgin and the Evangelist, and the unnatural posture of the Baptist are signs of the increasing mannerism of Botticelli's style.

Plate 32 *The Birth of Venus.* c. 1485-86. Canvas. 68 × 109½ in. (172.5 × 278.5 cm.). Galleria degli Uffizi, Florence.
One of the Neoplatonic paintings owned by Lorenzo di Pierfrancesco de' Medici. Like the *Primavera*, a number of sources have been quoted from classical poets, one of the Homeric hymns, Lucretius, Horace, and Poliziano's *Giostra*, which gives a description of Apelles' lost painting, *Venus Anadyomene*. The painting symbolises the birth of the Venus-Humanitas of the Neoplatonists who represents a union of spiritual and sensuous qualities. The refinement of Botticelli's linear style, the sensuousness of his Venus and the unreality of her green and gilded world are a complete expression of this conception. Venus is a Gothic nude in form, although her gestures are those of the Classical *Venus pudica*. The marvellous, convoluted shape of the winds is his own imaginative conception.

Plates 33, 34 *Venus and Mars*, and detail. c. 1485-86. Panel. 27¼ × 68¼ in. (69 × 173 cm.). National Gallery, London.
This, like other paintings of the Neoplatonic group, had a different, or perhaps it would be truer to say, an additional meaning for the original owners, which is unknown to us now. The alert Venus watching a slumbering Mars can be explained by a commonplace of Neoplatonic thinking: love and harmony have a beneficient power over war and discord. E.H. Gombrich quotes from Marsilio Ficino in support of this idea: 'Venus seems to master and appease Mars, but Mars never masters Venus'. The goddess is the Venus-Humanitas of the *Primavera* and other Neoplatonic paintings

(introduction page 12). The unusual composition of the reclining figures may have been borrowed from a relief, like the motif on a second century A.D. sarcophagus in the Vatican of Bacchus discovering Ariadne at Naxos, in which the figures of a man and woman are lying in this position.

Plate 35 *Madonna of the Pomegranate*. c. 1487. Panel. Diameter 56½ in. (143.5 cm.). Galleria degli Uffizi, Florence. The tondo is still in its original frame carved with lilies, the emblem of Florence, and may have been painted for the audience hall in the Palazzo Vecchio. The Madonna is characteristic of the mannered mother of this period. Her abstracted air is the more marked in contrast with the vital, individual angels.

Plate 36 *Altarpiece of San Barnaba*. c. 1488. Panel. 8 ft. 9½ in. × 9 ft. 2 in. (268 × 280 cm.). Galleria degli Uffizi, Florence. The upper part above the roundels and a strip from the foreground were cut off, replaced in 1717 by Agostino Vivacini and removed again when it was taken to the Uffizi, so that the painting now appears out of proportion. It is not one of Botticelli's most successful paintings even without this mutilation. The Virgin and Child are lifeless, there is an artificial busyness about the angels holding the instruments of the Passion, and St Catherine is the only one of the saints who possesses any real vitality.

Plate 37 *St Augustine's Vision of the Child on the Shore*. c. 1488. Panel. 7⅞ × 15 in. (20 × 38 cm.). Galleria degli Uffizi, Florence. One of the four surviving panels from the predella of the San Barnaba Altarpiece. It illustrates the story of how St Augustine was walking along the shore, trying to understand the mystery of the Trinity, when he came upon the child, who told him that he was going to pour the ocean into the hole he had made in the sand. When the saint gently remonstrated with him for his folly, the child replied that it was easier for him to accomplish his task than for Augustine to solve the mystery of the Trinity, and then vanished.

Plates 38, 39 *Annunciation*, and detail. c. 1489-90. Panel. 59 × 61½ in. (150 × 156 cm.). Galleria degli Uffizi, Florence. To the end of his career, Botticelli remained almost as much a gothic artist as he was a man of the new age. The two attitudes are generally completely fused, but here they are distinct. The strong perspective lines of the flags and the rectangle of the window have the geometric severity of Piero della Francesca, but the view beyond on to a half-built bridge and a turretted castle, rising like an exhalation among the cloudy hillocks of a medieval landscape, are pure fancy. The elaborate folds of the angel's robes are Gothic and the exquisite attitude of the Virgin is a Gothic arabesque turned into a Botticellian mannerism.

The landscape detail shown in plate 39 is typical of the formalised north European view that Botticelli borrowed from Flemish painting.

Plate 40 *St Augustine in his Study*. c. 1490. Panel. 16⅛ × 10⅝ in. (41 × 27 cm.). Galleria degli Uffizi, Florence. Botticelli frequently painted St Augustine but, except in this rather endearing version, he appears as the formidable doctor of the Church. The colours, yellow-green of the curtain, yellow tone in the cloak against the blue-grey masonry, are particularly harmonious.

Plate 41 *Calumny*. c. 1494-95. Panel. 24½ × 36 in. (62 × 91 cm.). Galleria degli Uffizi, Florence. We know from one source or another several names of princely patrons or religious institutions who commissioned

Botticelli's paintings. No doubt he sometimes gave them away, but this is the only one that we know for certain was presented to a friend. Vasari said that he gave a painting 'representing the Calumny of Apelles... of the utmost beauty... to his close friend, Antonio Segni' accompanied by a quatrain in Latin, which he composed himself. Other sources identify it with this work. Alberti had suggested in his *Della Pittura* that painters should take this subject from one of Apelles' lost works and gave a brief description of it, but Botticelli's source was evidently a translation of Lucian's *De calumnia*, probably that of Bartolomeo Fontio published in 1472, which describes Apelles' painting. Lucian's details of a 'man with ass's ears almost as long as Midas's stretching forth his hand to Calumny' is not given by Alberti. Calumny is the woman holding a torch in one hand and dragging her victim by the hair with the other. The man leading her on is Hate. The handmaidens, arranging her hair, are Deceit and Fraud. The women whispering into the king's ears are Ignorance and Suspicion. Truth stands naked on the extreme left, watched by Penitence. The subjects of the reliefs are varied and have no connection as a whole with the main theme. He touched them with gold because it was the practice then to gild bronze reliefs. Pictorially, it merits a great measure of Vasari's praise: as an allegory, it is a curious performance. There is nothing evil about the four female vices facing the observer, but Penitence is the most sinister figure of the whole group. Hate is in character, but it is the only naturalistically painted figure of them all. Botticelli was a great painter of mythology, but not of allegory, if he can fairly be judged by his one attempt.

Plate 42 *The Story of Virginia*. c. 1499. Panel. 33⅞ × 65 in. (86 × 165 cm.). Galleria dell'Accademia Carrara, Bergamo.
Vasari said that 'in the house of Giovanni Vespucci in the via de' Servi... [Botticelli] did a number of pictures round a room, framed in an ornamental border of walnut'. The house, in fact, was bought by Giovanni's father, Guidantonio. This painting and the *Tragedy of Lucretia* may be among these pictures. They belong, anyway, to the same kind of decoration. The story is similar to the tragedy of Lucretia. Appius Claudius, one of the decemvirs, wished to possess Virginia, whose father, Virginius, was fighting in the army some way from Rome. When the advances of Appius were repulsed, he sent one of his minions, Marcus Claudius, to claim the girl as his slave (scene on extreme left). (Left centre) Marcus takes Virginia to the tribunal to make good his cause. Appius, presiding over the court, where her father has now arrived (centre back), gives judgment in favour of Marcus. Virginius kills his daughter (right centre) to prevent her violation and then takes horse (extreme right) back to camp. There he rouses the army to revolt against the iniquitous rule of the decemvirs (centre). The frenetic gestures of the figures, especially where Marcus takes Virginia away and where she is murdered, are the extreme development of Botticelli's late mannerism. He has arranged the six scenes into a neat, if rather crowded, narrative sequence but in this and the Lucretia panel, he is sometimes criticised for the disproportion between the overwhelming architectural setting and the tiny figures. Although they were not intended for *cassoni* (painted chests), he was following the same tradition when he painted them. *Cassoni* paintings were nearly always narrative in character and, when the scene was set in landscape, it often occupied more space than the incident itself.

Plate 43 *The Tragedy of Lucretia*. c. 1499. Panel. 31½ × 70 in. (80 × 178 cm.). Isabella Stewart Gardner Museum, Boston.
This, like the *Story of Virginia*, may be one of the decorative panels done for the house of Guidantonio Vespucci (plate 42).

On the left, Lucretia tries to resist Tarquin; on the right, she kills herself; and in the centre, Brutus tells the Romans of Tarquin's crime and rouses them to revolt. Botticelli was evidently far more interested in painting the splendid setting of fantastic architecture than in the narrative and, as in the Virginia panel, he is following the *cassoni* tradition in subordinating the figures to the setting. The statue in the centre is of Judith, a rather different example of womanly fortitude from Lucretia herself.

Plate 44 *Miracles of St Zenobius*. c. 1500-05. Panel. 25½ × 54¾ in. (65 × 139.5 cm.). National Gallery, London.
There are four panels altogether illustrating the saint's life and miracles, which were painted for the same kind of interior decoration as the Virginia and Lucretia panels. The National Gallery, London, also possesses a second panel of the series; the third is in the Metropolitan Museum, New York, and the fourth is in the Gemäldegalerie, Dresden. The episode on the left shows Zenobius releasing two men from the curse of gnawing their own flesh, which their mother had laid on them for ill-treating her. In the centre, St Zenobius resurrects a boy; his mother had left him in the saint's care, while she went on a pilgrimage to Rome, and the boy had died in her absence. On the extreme right, he cures a blind man who had promised to become a Christian if his sight were restored. The Zenobius panels are more restrained than the classical narratives and, although the figures are equally mannered, the explosive gestures are caught within the graceful curve that was a characteristic of Botticelli's late figure painting.

Plate 45 *Pietà*. c. 1490-1500. Panel. 42⅛ × 28 in. (107 × 71 cm.). Poldi-Pezzoli Collection, Milan.
There are examples of compositions with a compact mass of figures to be found in every period of Botticelli's work, but nothing approaching the involved concentration of this (introduction page 21). It is common in relief sculpture, but there are few parallels in painting until sixteenth century mannerism.

Plate 46 *Pietà*. c. 1490-1500. Panel. 43¼ × 81½ in. (110 × 207 cm.). Bayerische Staatsgemäldesammlungen, Alte Pinakothek, Munich.
Painted for the church of San Paolino. This explains the presence of St Paul and St Peter. The cone-shaped composition of the main group is fundamentally the same as in the Milan *Pietà*, but it has opened out and the emphasis is horizontal instead of vertical. This in itself would lessen the tension; the addition of the three male saints, who are conventional presences without any real connection with the entombment, almost puts the painting into the same class as the traditional *sacra conversazione*. Possibly the Milan version was done first for a private patron, who allowed Botticelli more latitude.

Plate 47 *Last Communion of St Jerome*. c. 1496-1500. Panel. 13 × 13¾ in. (33 × 35 cm.). Bequest of Benjamin Altman, 1913. Metropolitan Museum of Art, New York.
The *Anonimo Gaddiano*, an early sixteenth century chronicle, records that Botticelli made 'very many little works which were most beautiful and, among the rest, a St Jerome, a singular work'. There is no evidence that this is a reference to this particular painting, but it is a revealing comment on the kind of small devotional work produced in some numbers by Botticelli and his workshop; hardly any religious paintings from his hand with these tiny dimensions survive today. It would be interesting to know why the chronicler thought this, or one of its versions, was a 'singular work'. Nothing could be more hazardous than to interpret the critical attitudes of an unknown writer who lived over four centuries

ago, but it is safe to assume that he was implying a comparison with the familiar types of religious painting. Beside these, the singular quality of the *St Jerome* is the complete concentration on the priest's action in a setting stripped of everything except the essential symbolic objects, so that nothing should distract the attention from this. The absorption of the three monks and the acolytes, the forward movement of the near acolyte and priest stressed by the sweeping lines through the alb and chasuble up to the priest's hand, are a welding of action and linear structure that lends emotional power to so much of his late work, notably the last two versions of the *Adoration of the Magi* (plates 10, 11) and the separate incidents of the *Miracles of St Zenobius* (plate 44).

Plate 48 *Mystic Crucifixion.* c. 1501. Canvas. 28¾ × 20 in. (73 × 51 cm.). Fogg Art Museum, Cambridge, Mass.
Botticelli's only painting that is probably connected with Savonarola. Fulminations against the abuses of the Church, the evil ways of Florence, the call to repentance and prophecies of a great disaster that would purge and punish were common themes in his sermons. Savonarola frequently described his visions, which were awful allegories of how this would come about. The painting contains some of their typical imagery and more than one passage has been quoted from them as a source. In his *Compendio delle Rivelazioni*, he describes how he saw the Cross of God's Wrath 'trouble the heavens and drive clouds through the air, and cast winds and lightning and thunderbolts, and rain down hail, fire and swords, and kill a great multitude of people, so that few remained on the earth'. In another vision, he recounted: 'I saw a sword over Italy, and it trembled, and I saw angels who came and had red crosses in their hands'. The city in the painting is Florence; the cathedral, Baptistery, Orsanmichele and the Palazzo Vecchio are quite recognisable. The repentant Magdalen represents humanity, or more precisely

Florence. The angel is beating a fox, a symbol of vice, or a lion, an emblem of Florence. The precise meaning of the painting is obscure, but the broad intention is clear. It has been badly damaged.

Plate 49 *Mystic Nativity.* 1501. Canvas. 42½ × 29½ in. (108.5 × 75 cm.). National Gallery, London.
The pictorial meaning is plain. The birth of Christ, the Prince of Peace, brings redemption for mankind from original sin and reconciliation with heaven. The angels all carry olive branches as a sign of peace. In the upper part, they dance a carol of joy, a motif that Botticelli may have borrowed from Dante's *Paradiso*. In the middle, others lead the shepherds to worship at the manger and, in the foreground, three angels embrace three men as a symbol of reconciliation, while three stricken devils represent the end of Satan's dominion over mankind. Botticelli has followed the Nativity story in Luke II, and the familiar doctrinal interpretation. It is a more complex painting than his other versions of the Nativity, because he has painted the beginning of the Reign of Peace instead of the scene at the manger alone. The obscurities of the inscription in no way alter the familiar conceptions of the painting nor, it should be stressed, do they add to its appreciation. No explanation has been discovered of why Botticelli wrote it in Greek, which comparatively few people could read even in Florence. Had he used Latin, almost any educated person of that time would have understood it. The following is a translation: 'I, Alessandro, painted this picture at the end of 1500 during the troubles in Italy, in the half time after the time, according to the eleventh chapter of St John in the second woe of the Apocalypse in the loosing of the devil for the three and a half years. After that, he will be chained in the twelfth chapter and we shall see... [erased] as in this painting.'
 The Florentine year began on 25 March, so he painted

it in the early part of 1501 according to modern calculation. Lorenzo de' Medici's statesmanship had kept the peace in Italy, but after his death in 1492 the delicate equilibrium between the states was soon upset. If the 'half time after the time' covers one year and a half, 1499, which is a probable interpretation, the 'troubles' of 1499 were Louis XII's invasion of Italy and Cesare Borgia's military expedition into Romagna and his threat to Florence. 'The second woe' is described in Revelations XI, 1-13, in which the holy city is oppressed for forty-two months and two witnesses prophesy for 1260 days (forty-two months or three and a half years). The devil was not chained in chapter 12 but in chapter 20 of Revelations. The inscription has been given various Savonarolan interpretations because of its obscure, apocalyptic terms and because Savonarola was much given to prophesying disaster. But he was not unique in this (introduction page 19) and it is impossible to apply any part of the epigraph to the events connected with his death; for instance, three 'witnesses' were hanged on that occasion, not two. A reader, who has ploughed his way through this note and looked up the biblical references, may conclude that the inscription remains incomprehensible and has nothing to do with the painting, and he may well be right.

Plate 50 *The Agony in the Garden*. c. 1504. Panel. 20⅞ × × 13¾ in. (53 × 35 cm.). Capilla de los Reyes, Granada. Isabella the Catholic built the chapel in 1504 just before her death. This was among the paintings that decorated it. It is notable with other late works for the attention Botticelli gave to the setting (introduction page 21).

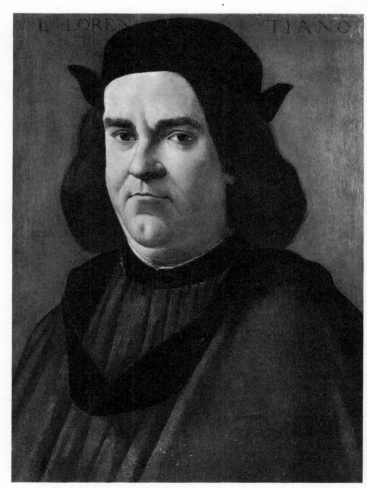

7 Portrait of Lorenzo Lorenzano

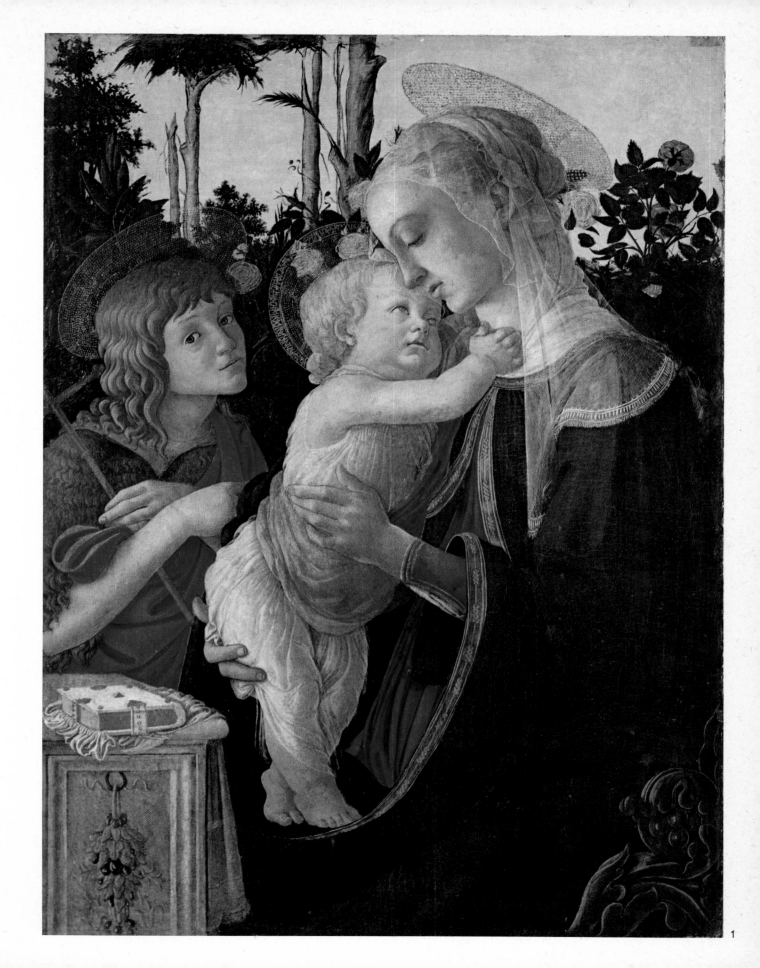

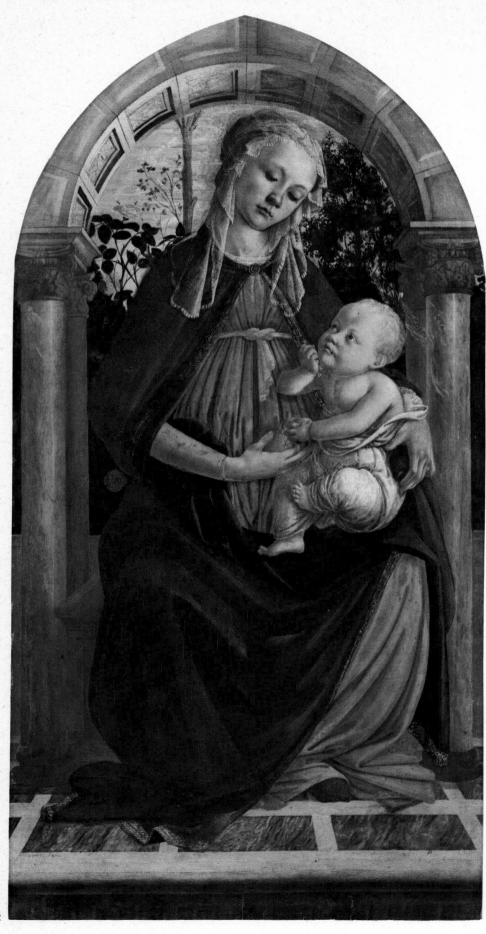

2

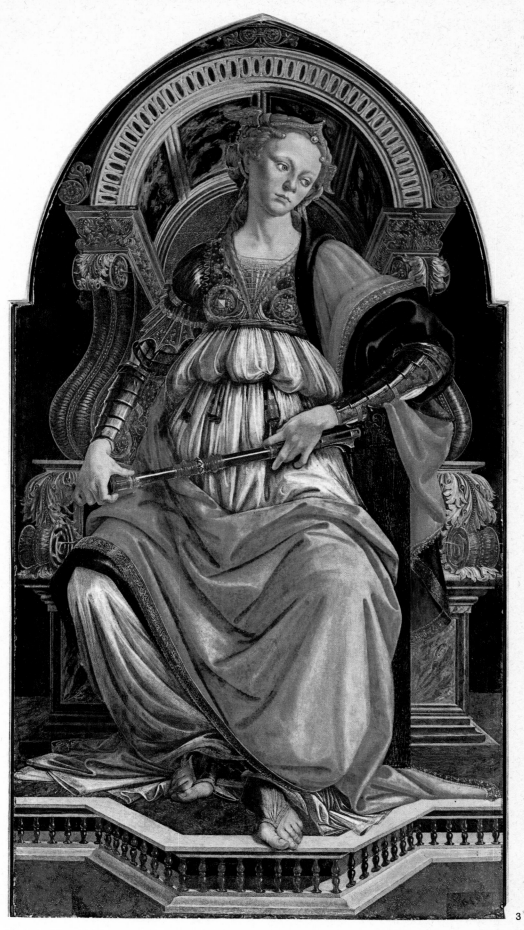

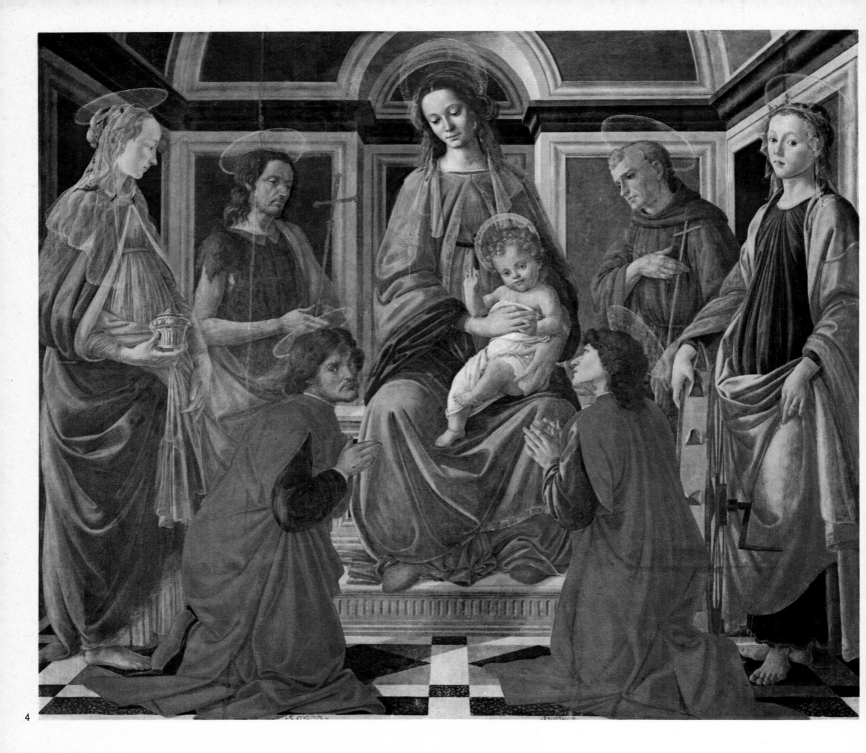

4

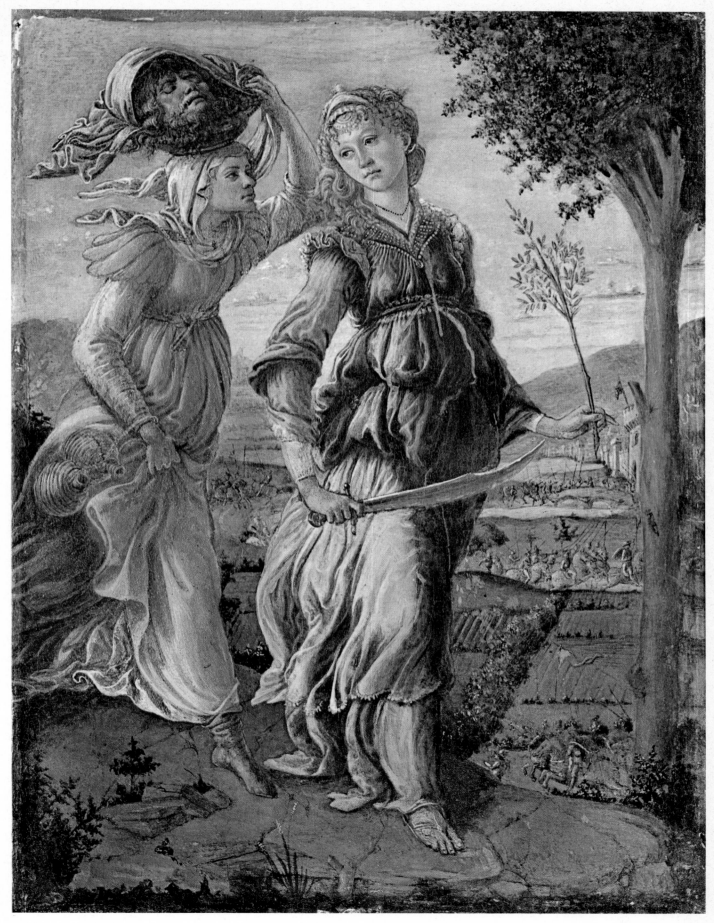

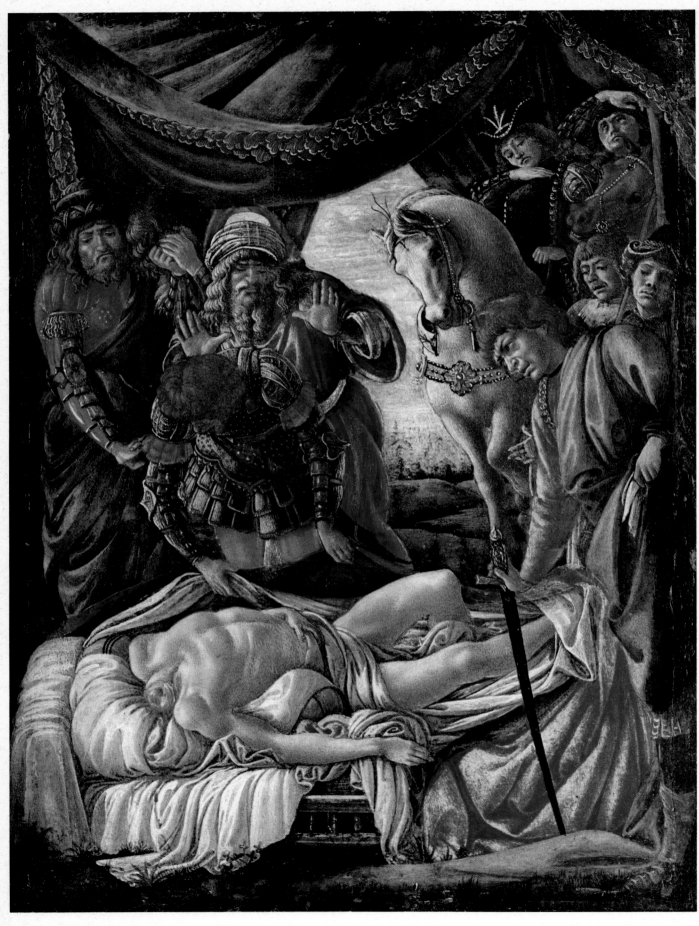

6

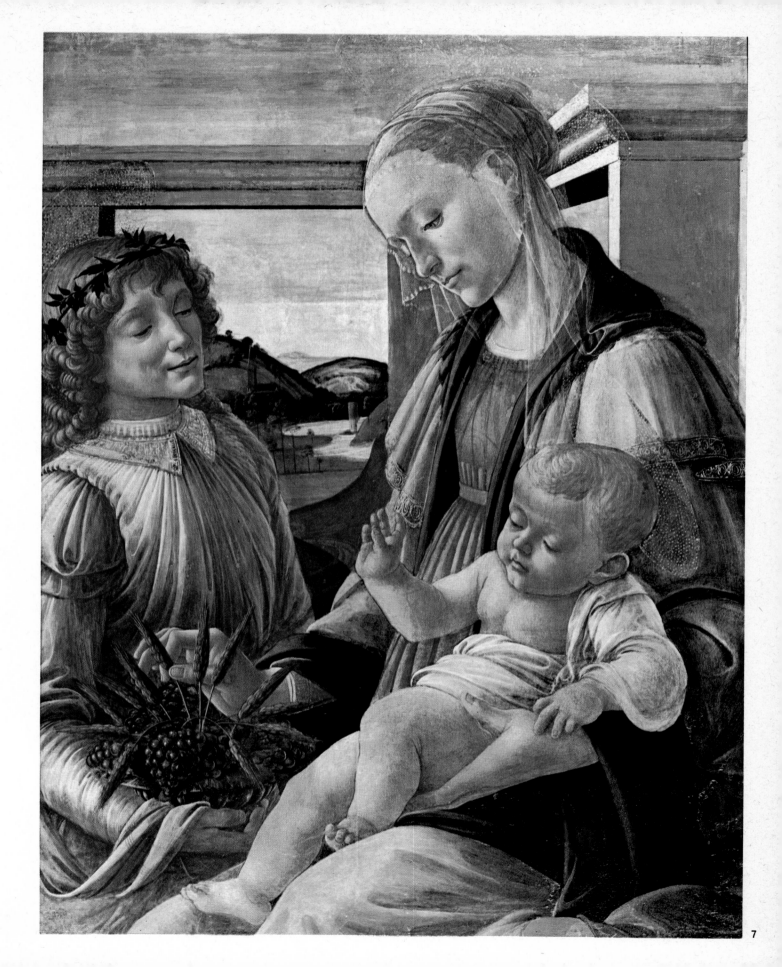

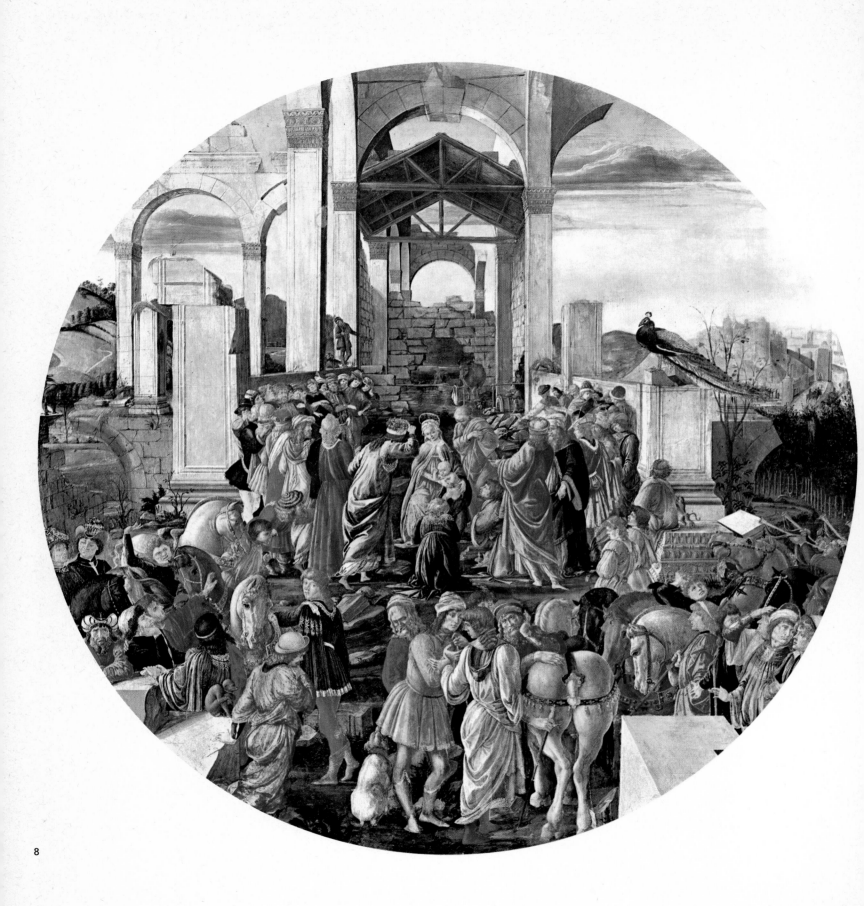

8

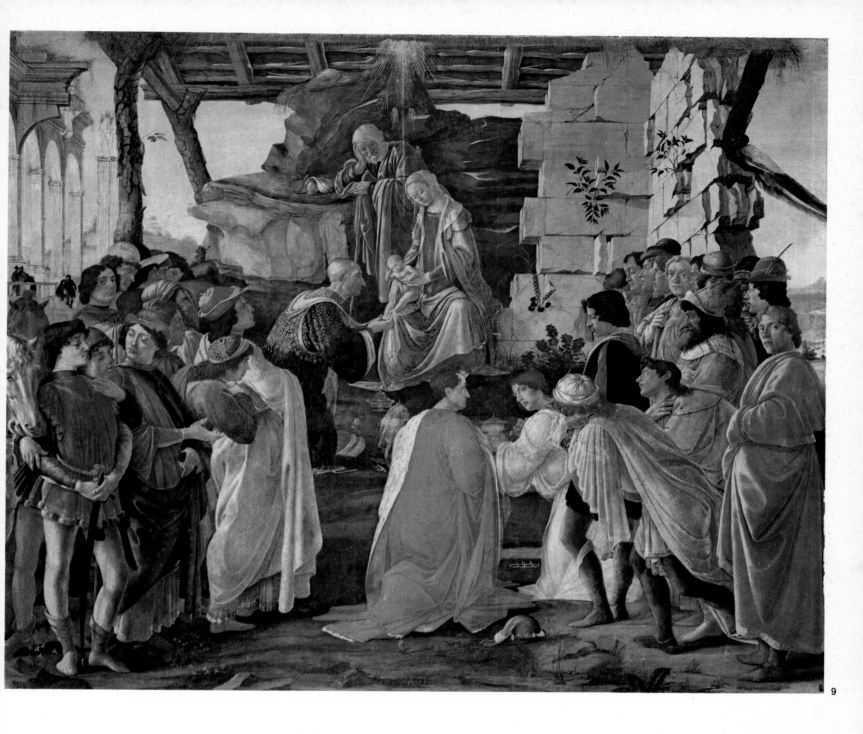

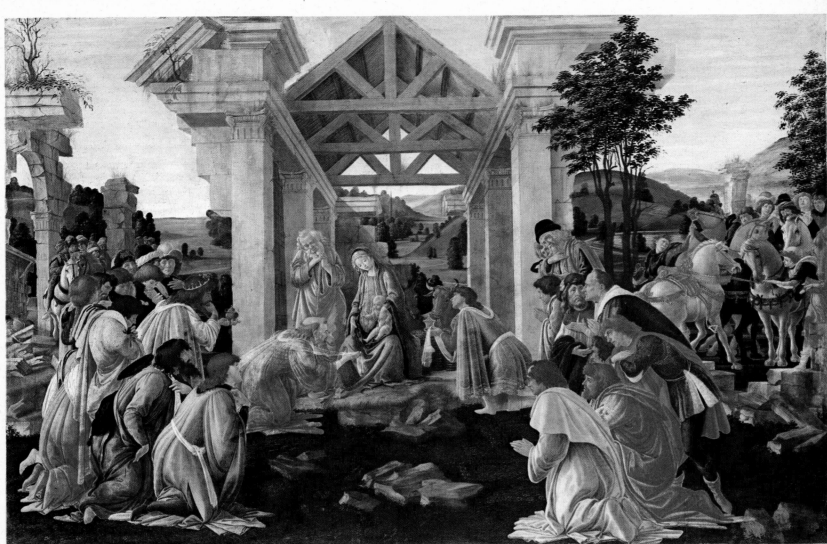

10

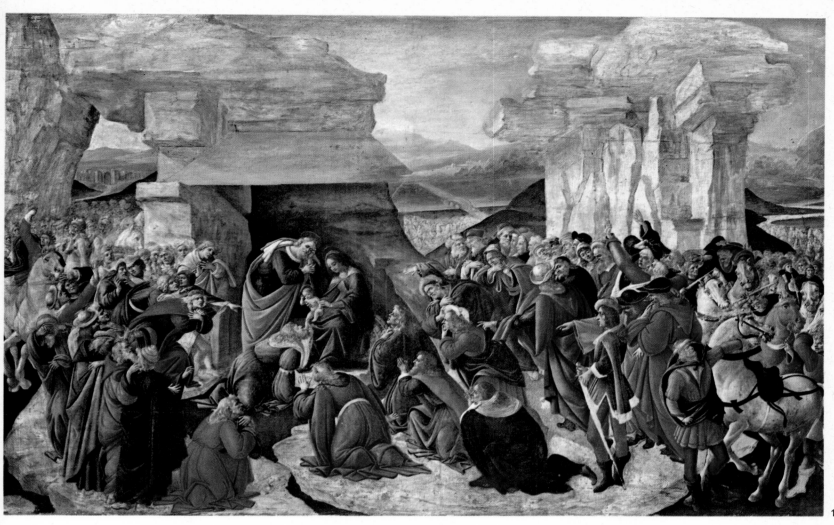

11

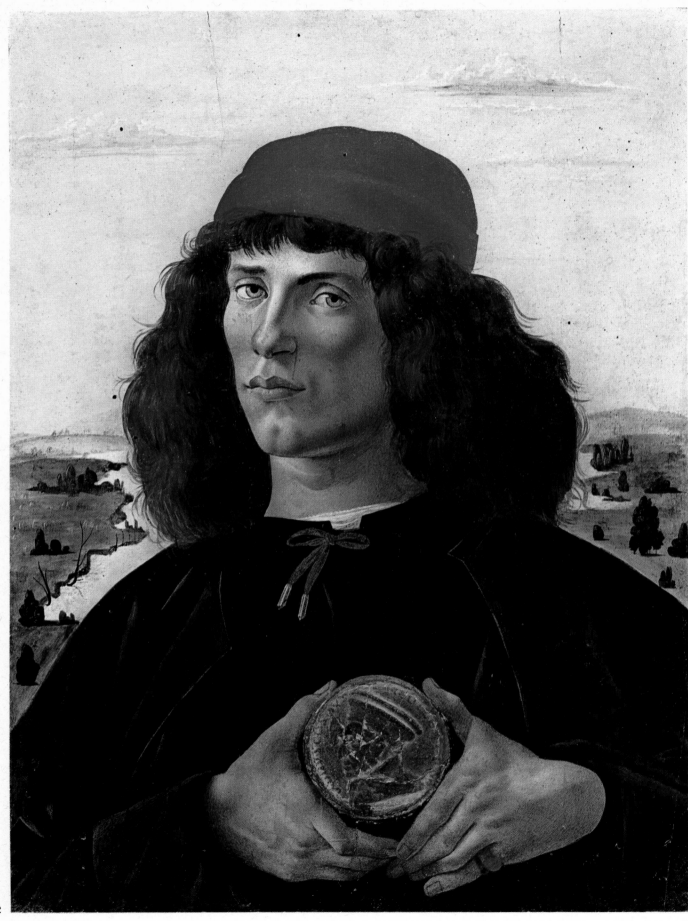

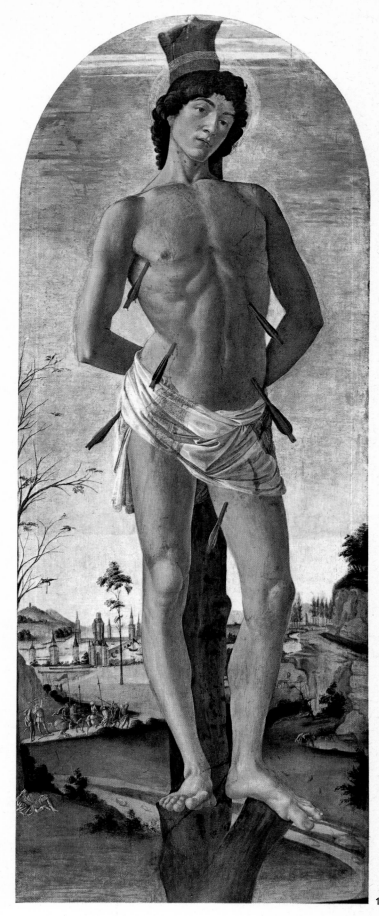

13

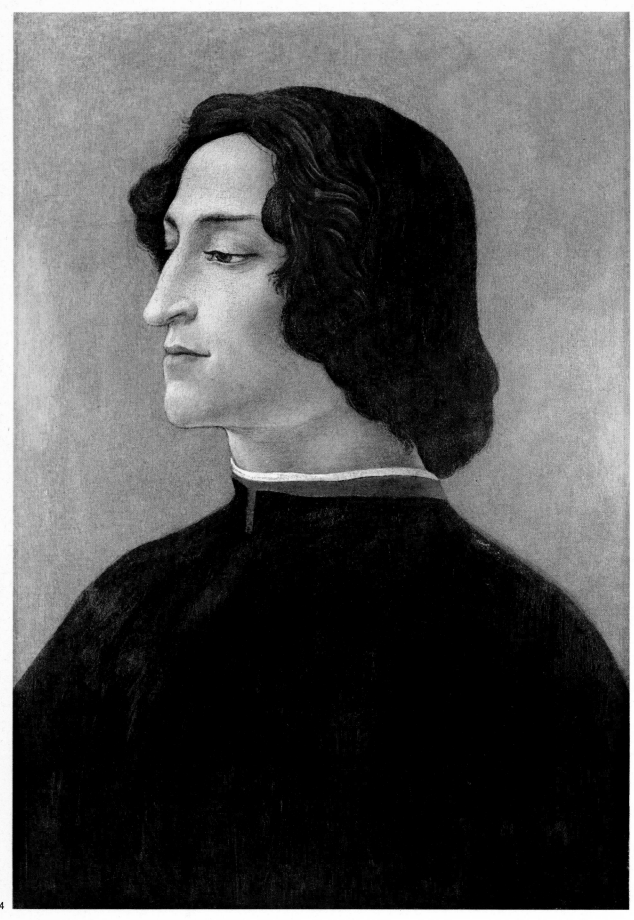

14

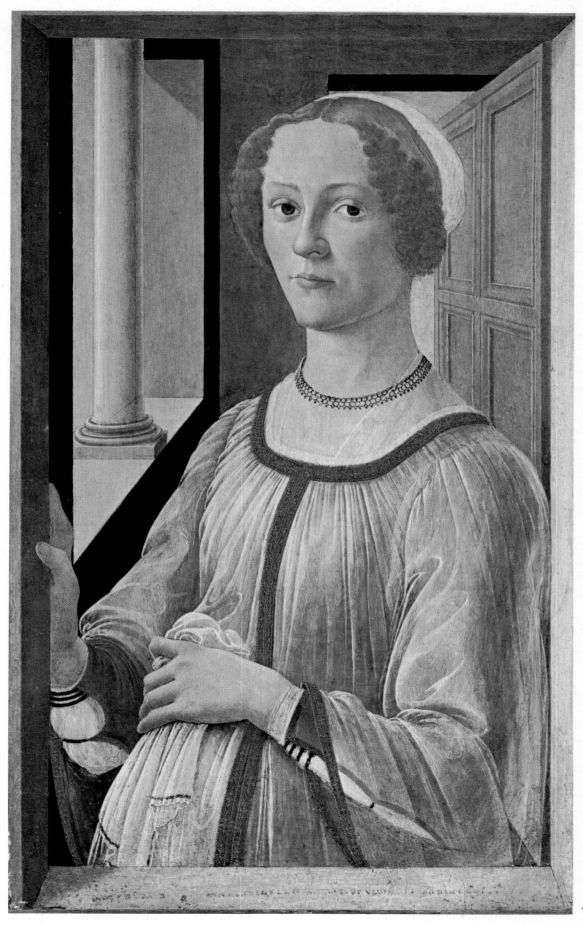

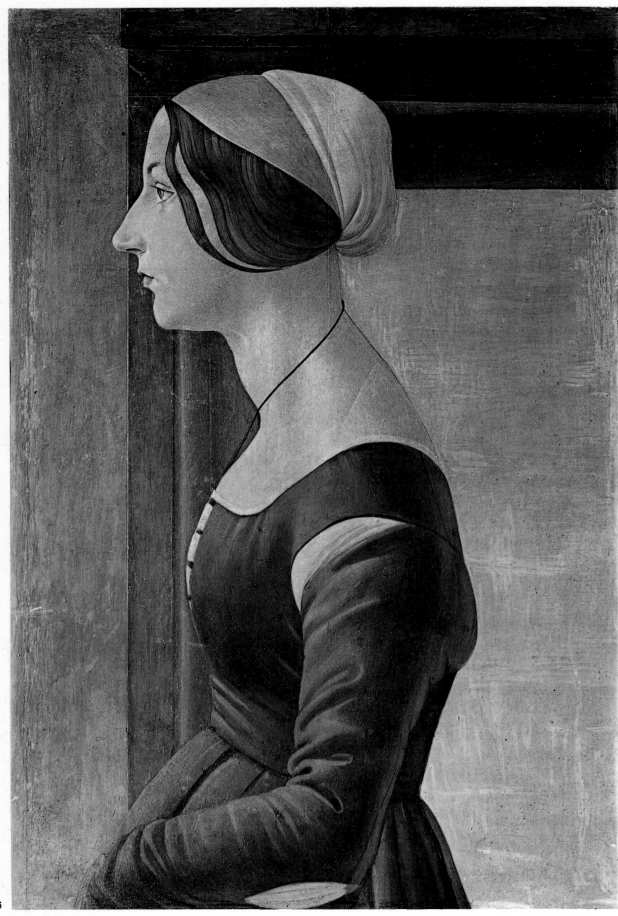

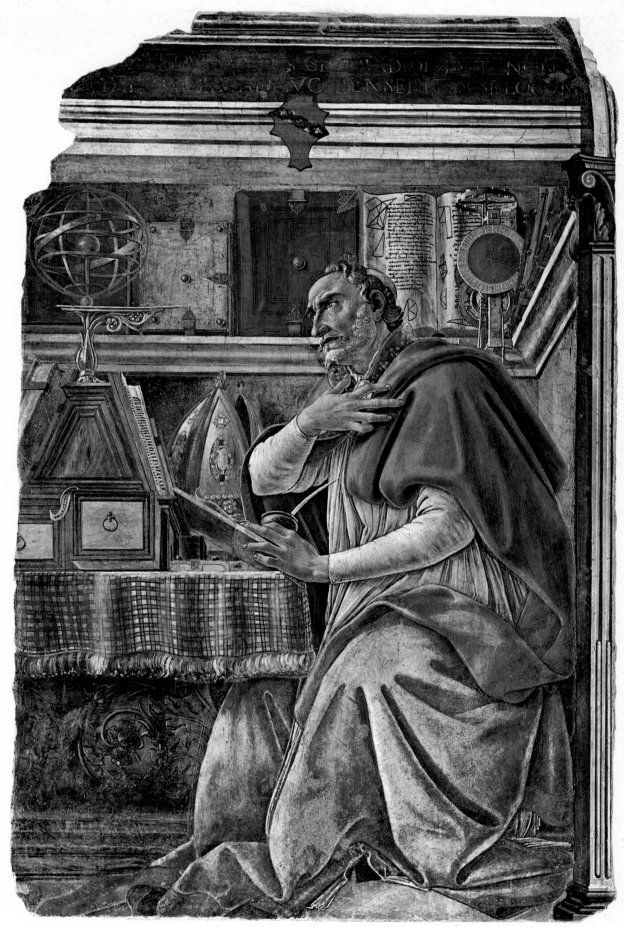

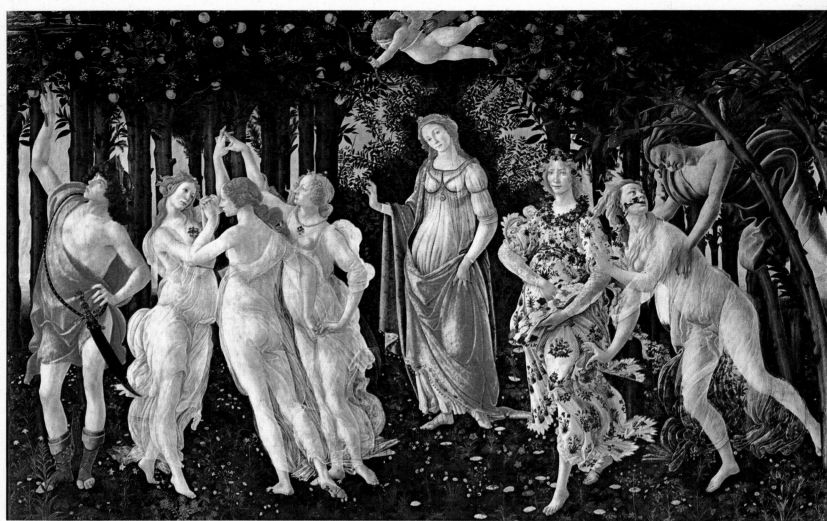

18

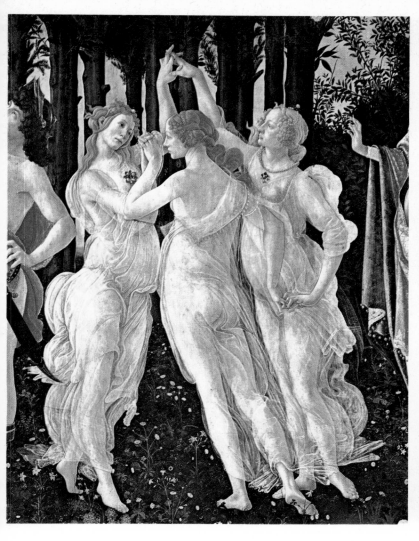
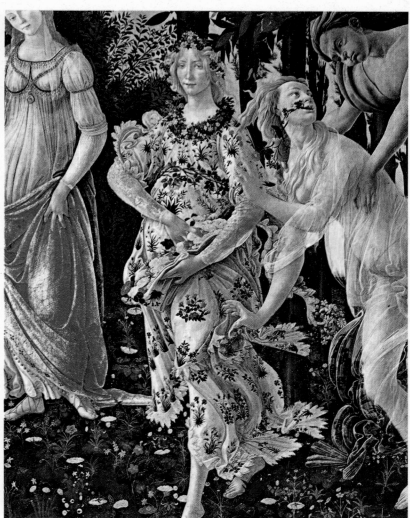

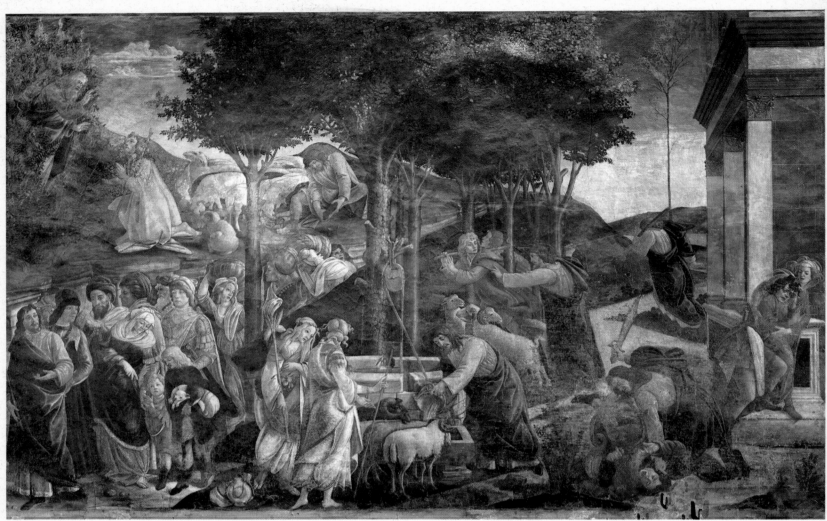

21

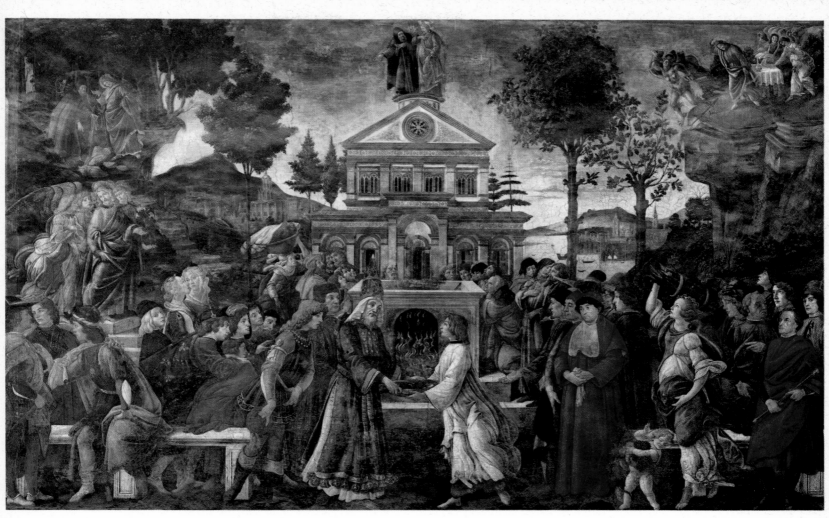

22

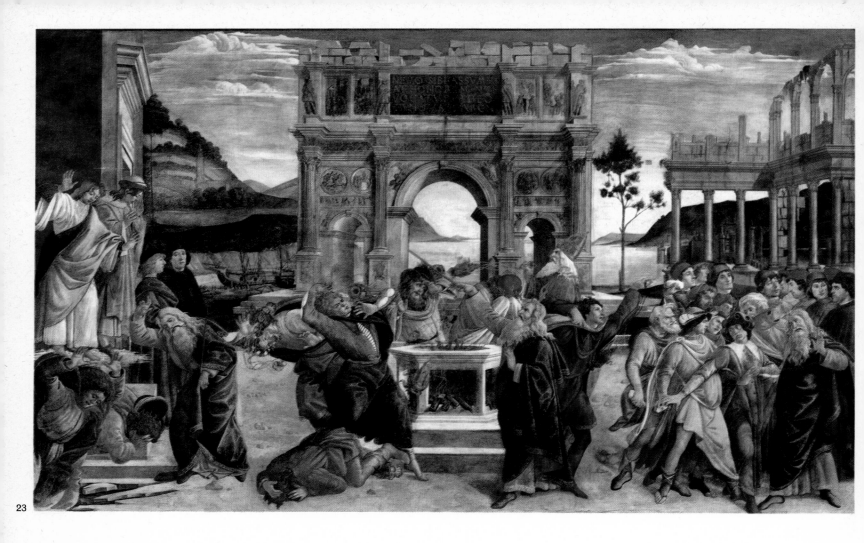

23

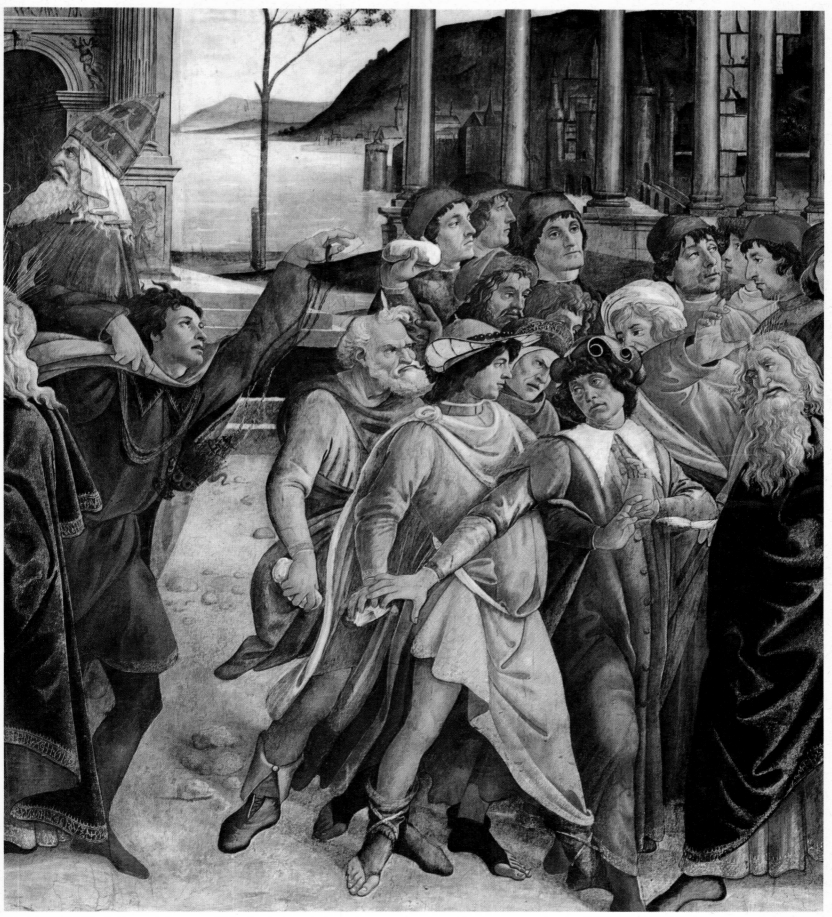

24

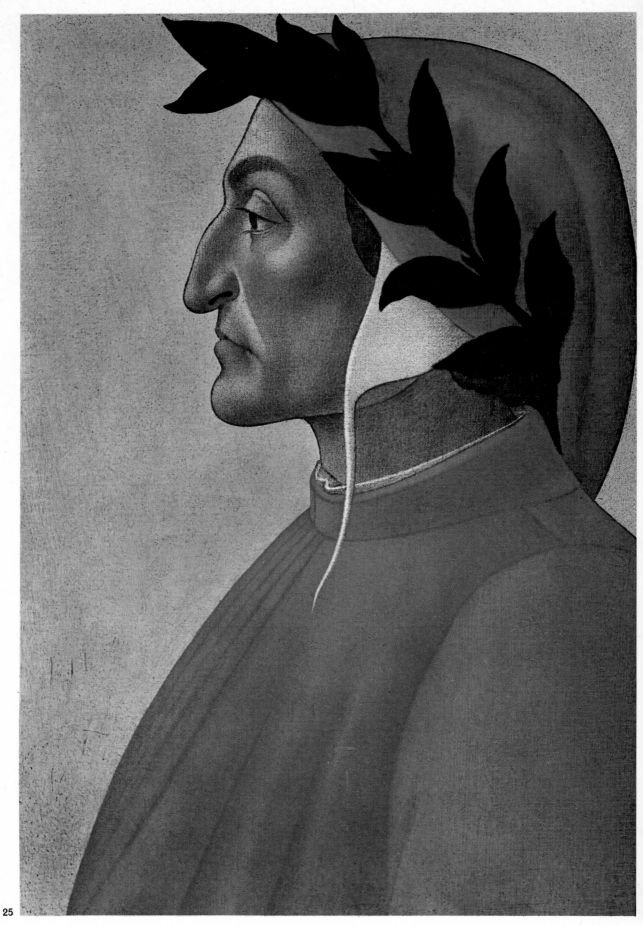

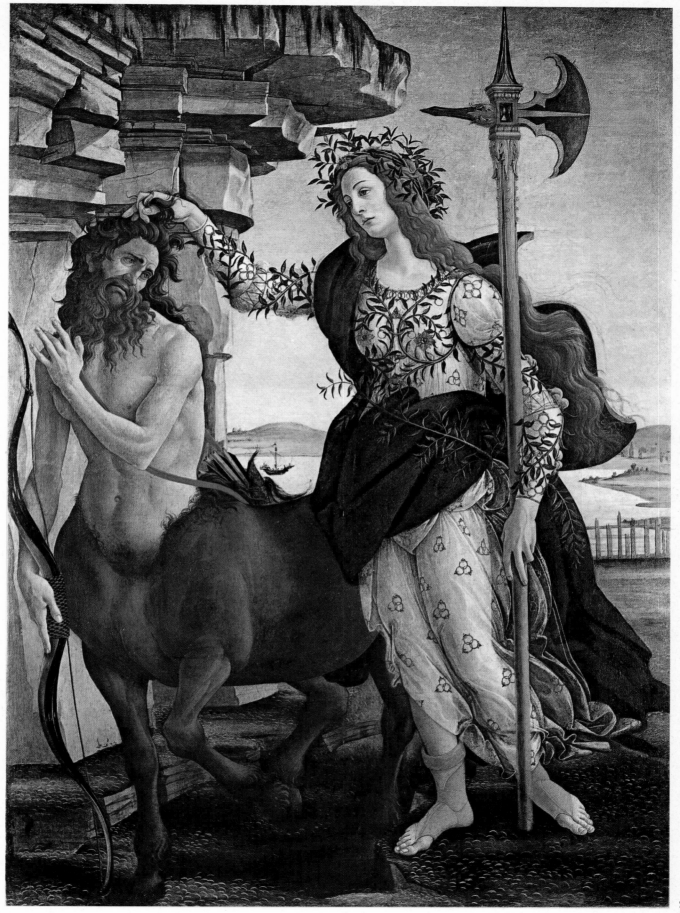

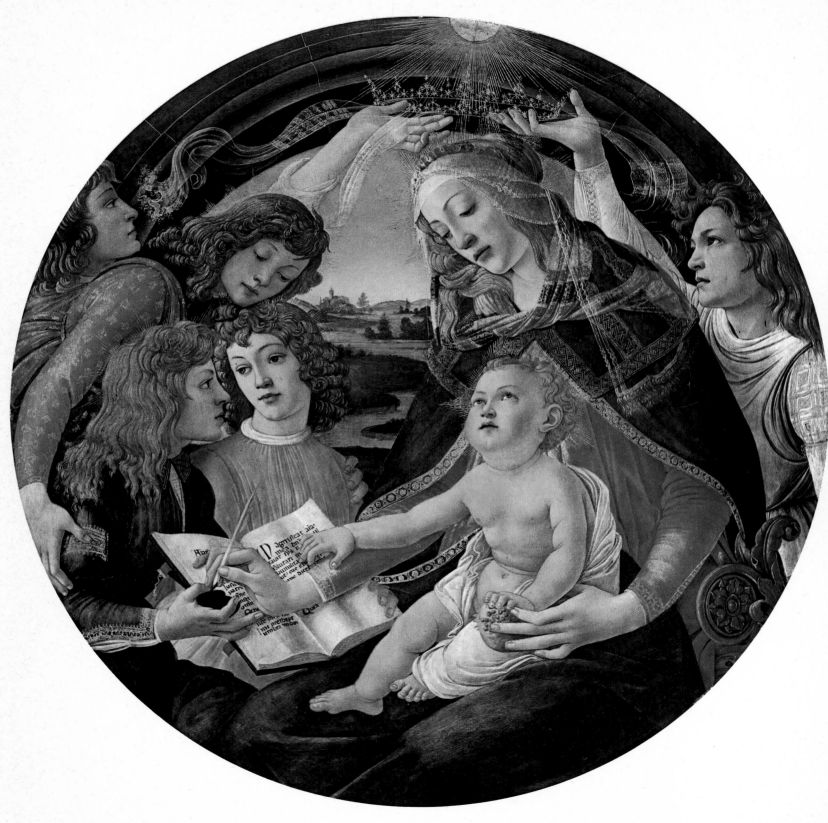

27

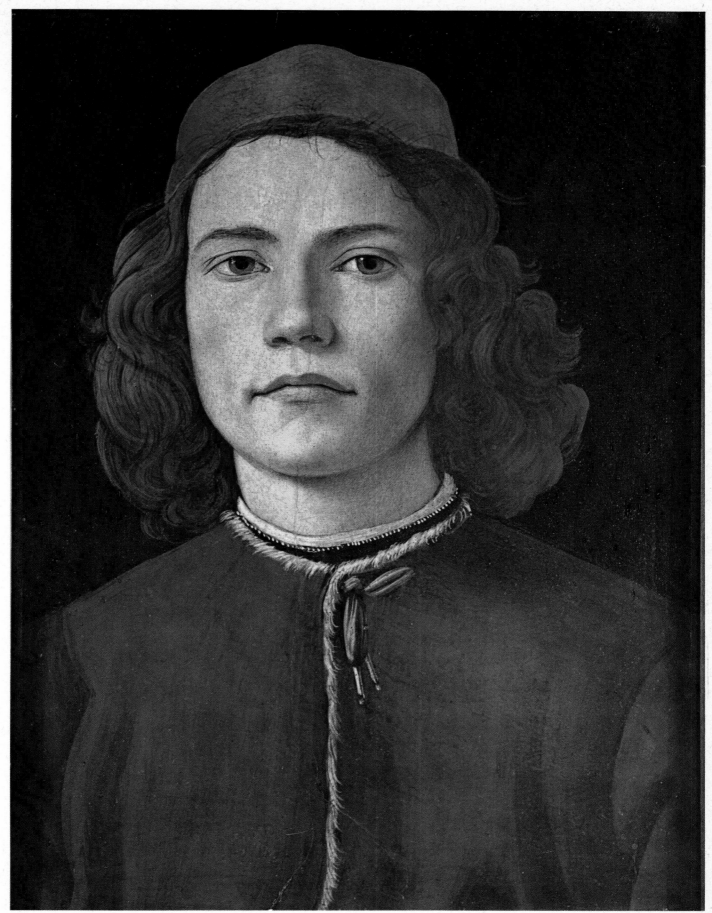

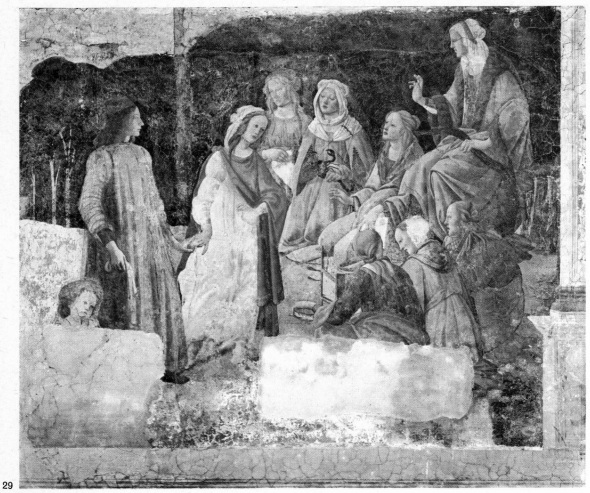

29

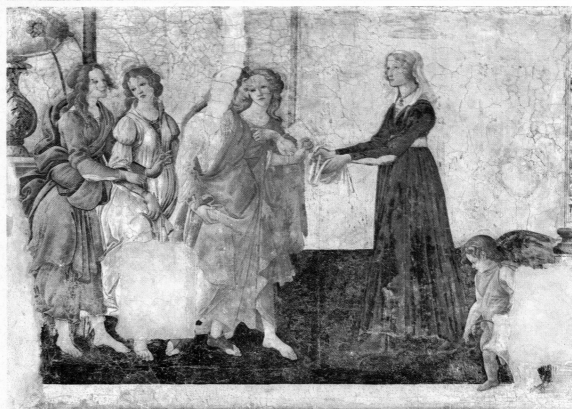

30

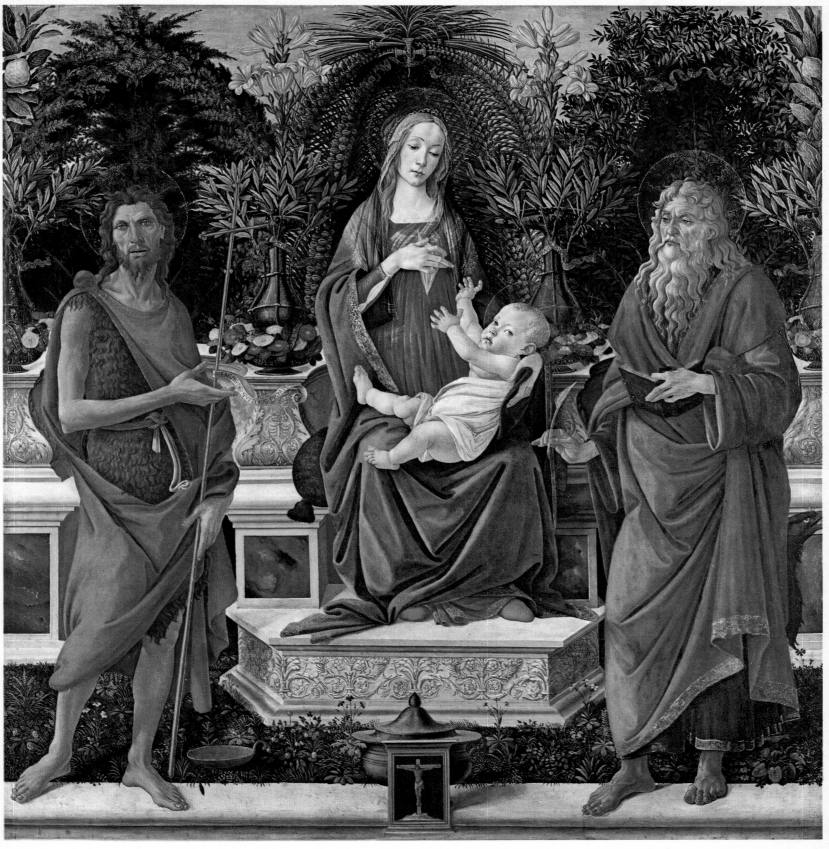

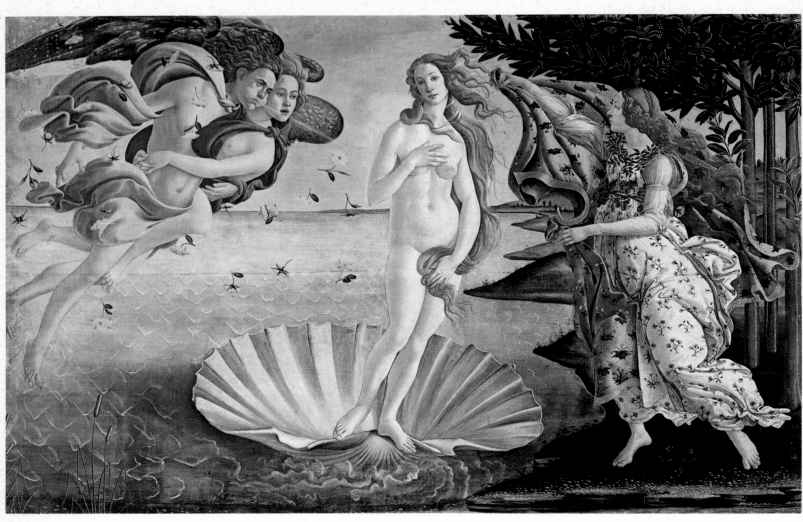

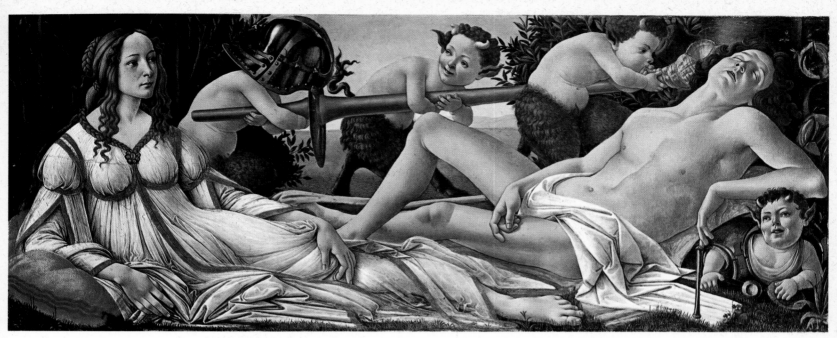

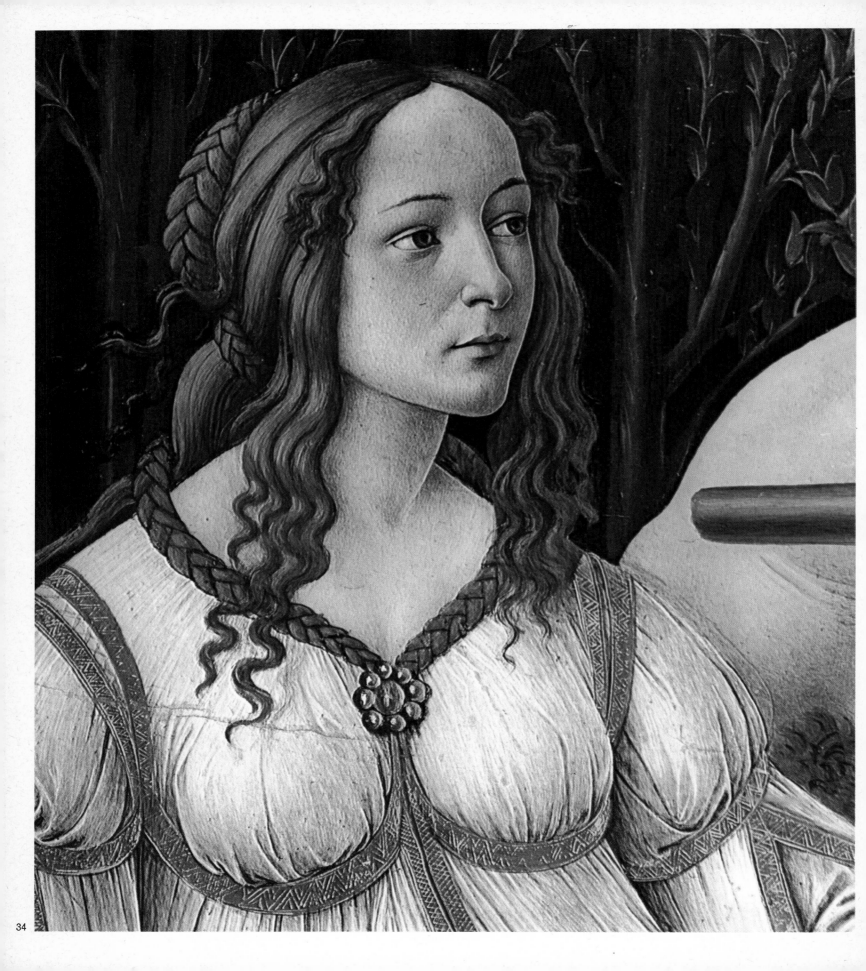

34

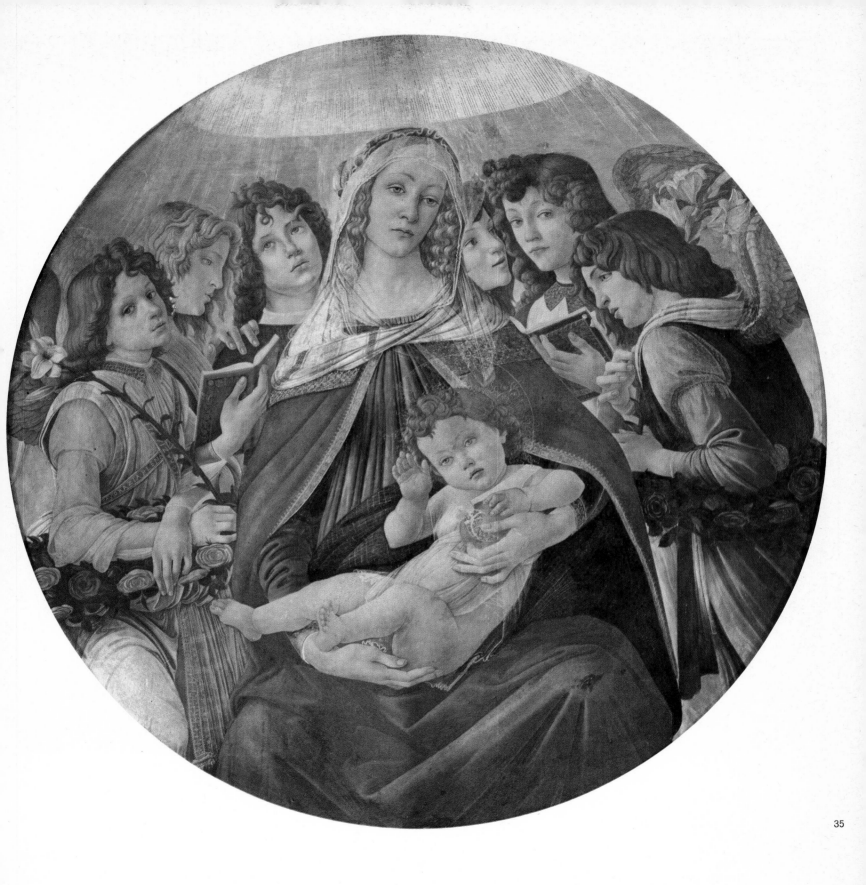

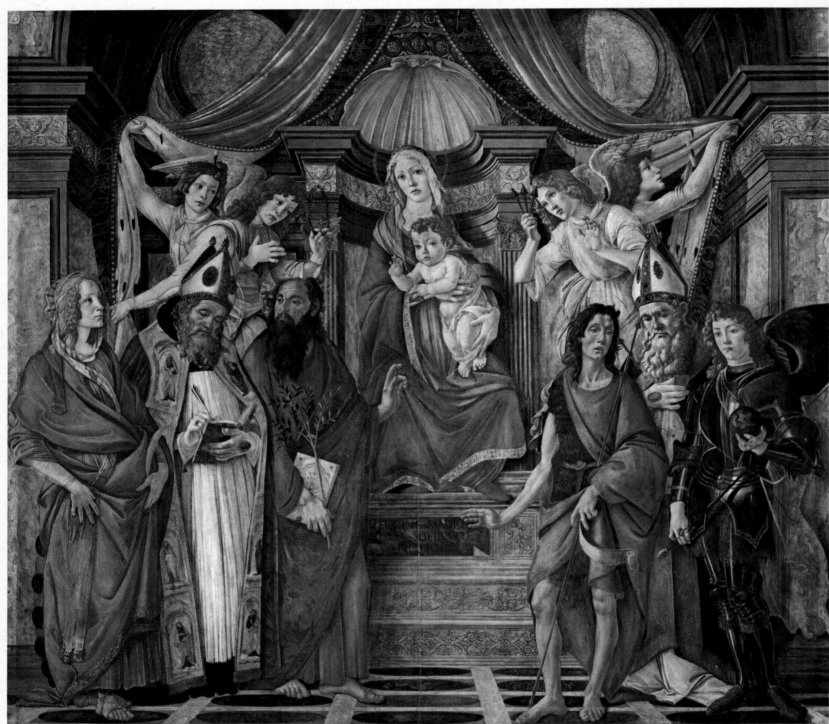

36

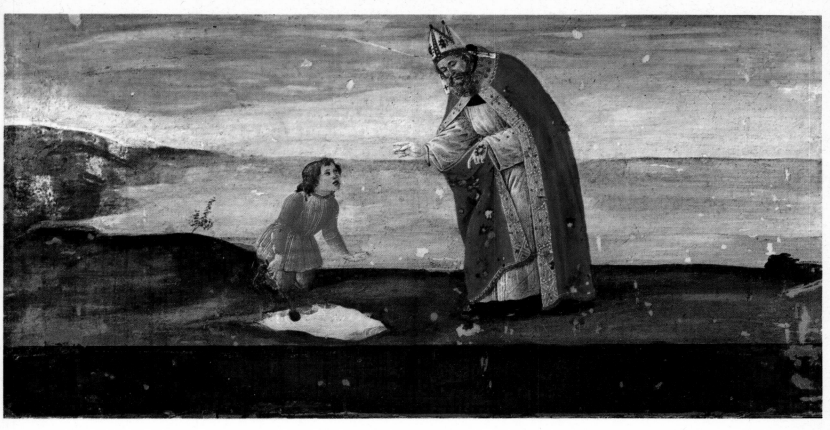

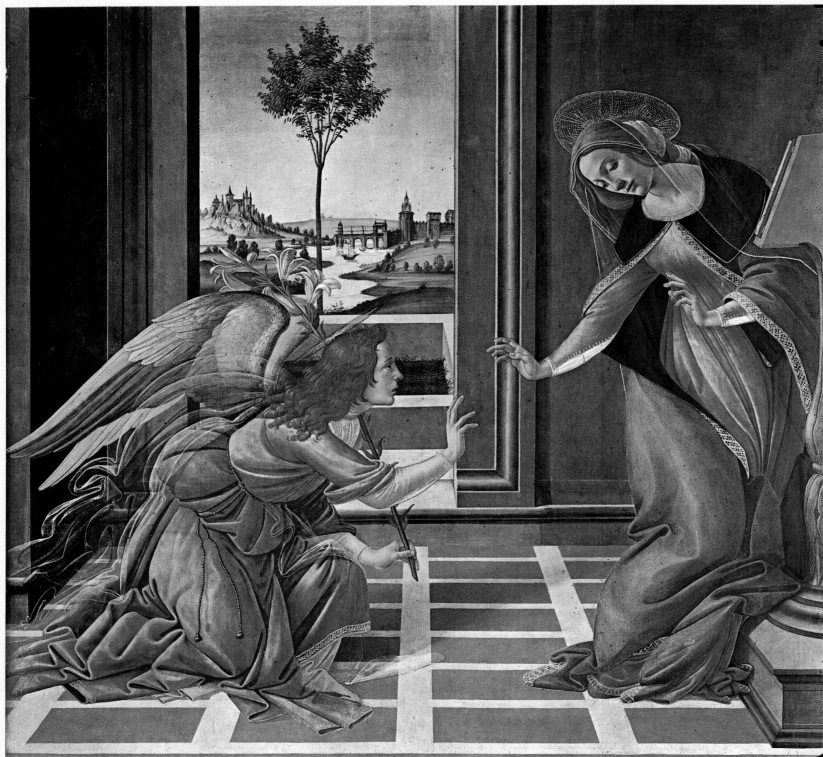

38

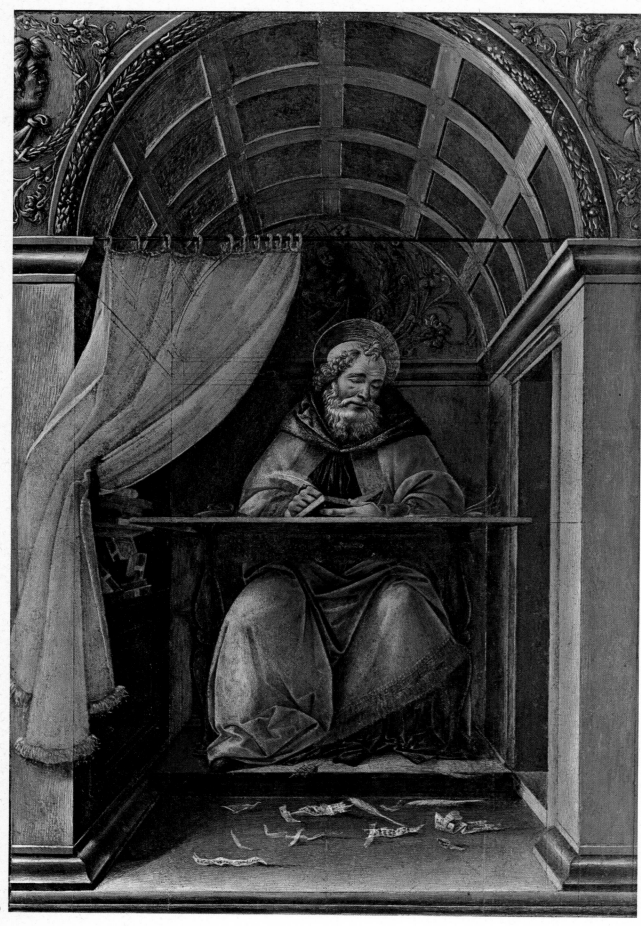

40

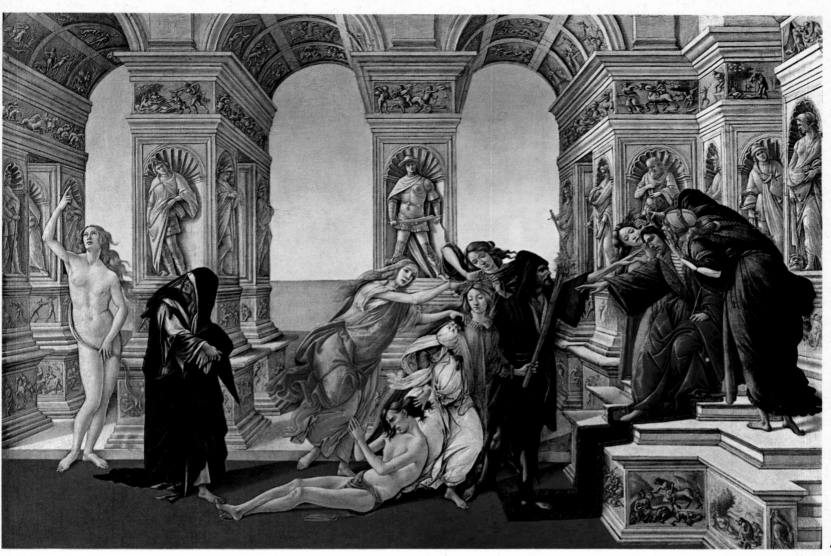

41

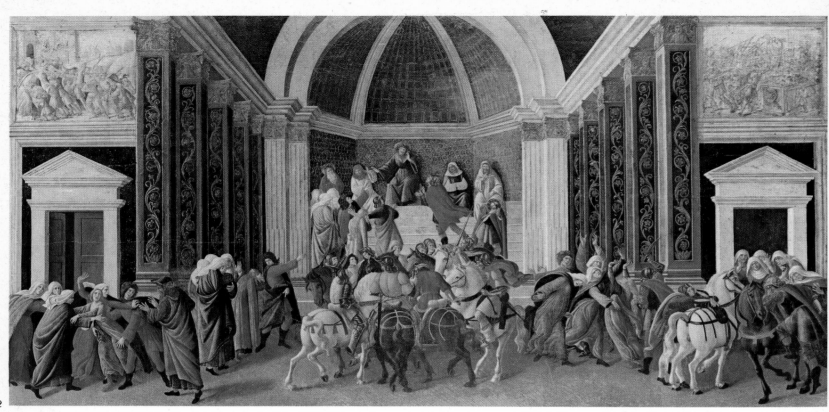

42

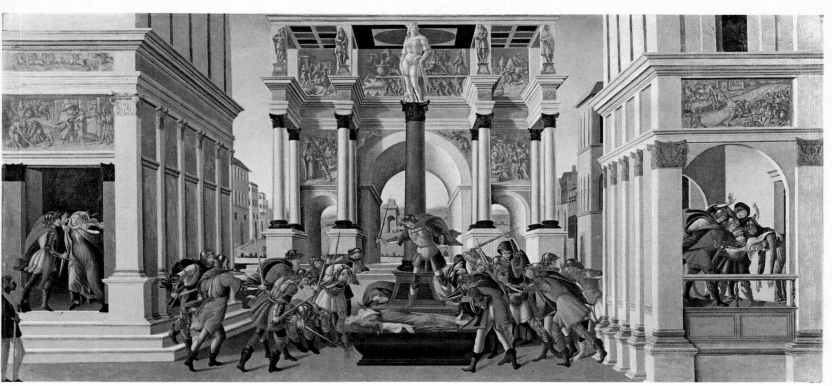

43

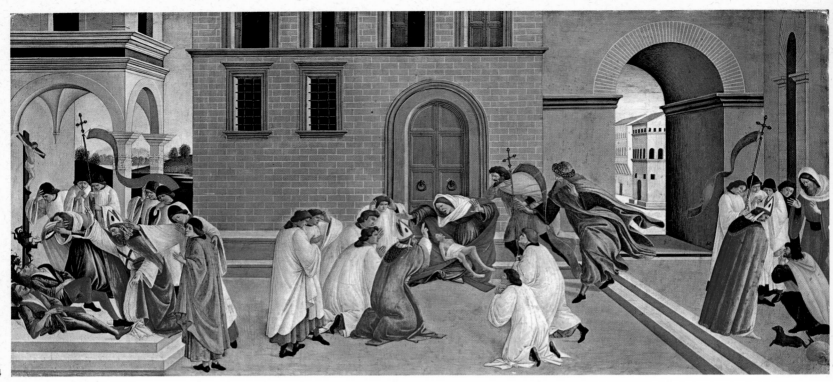

44

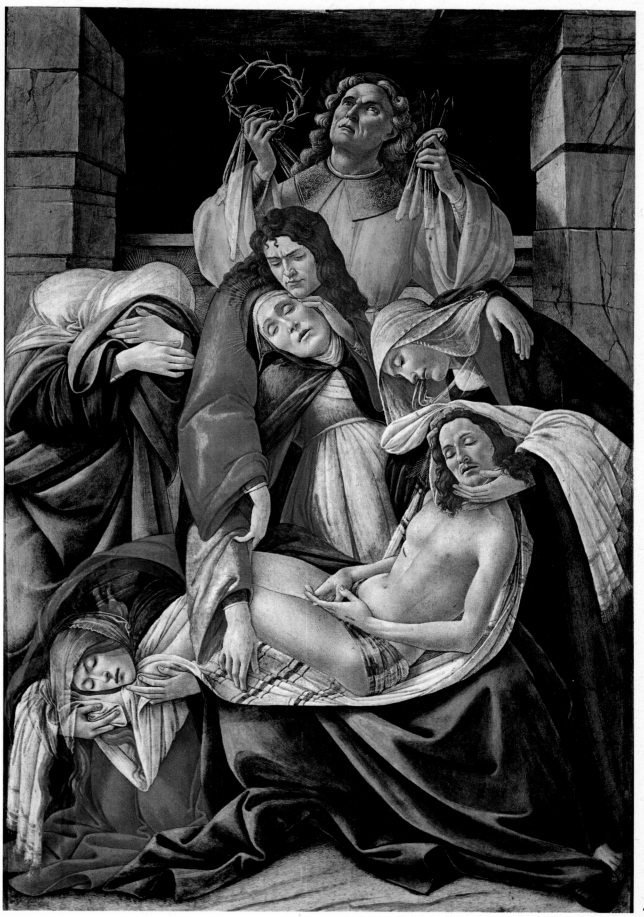

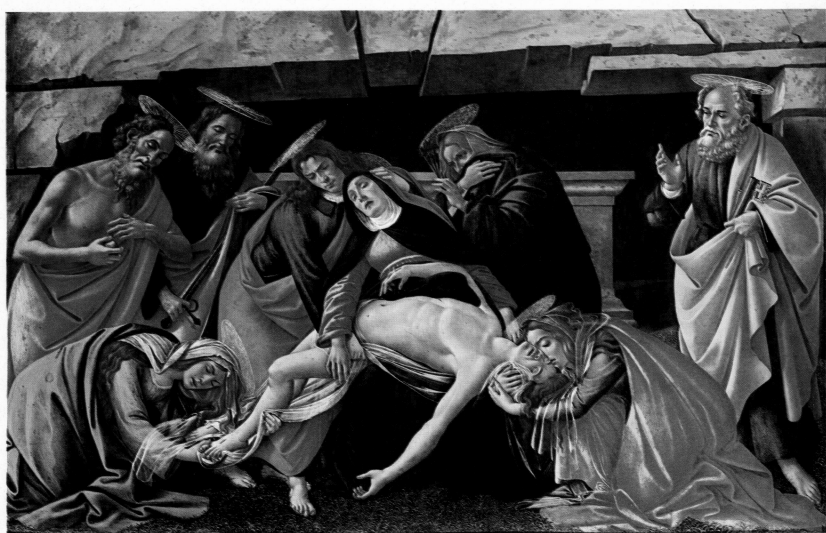

46

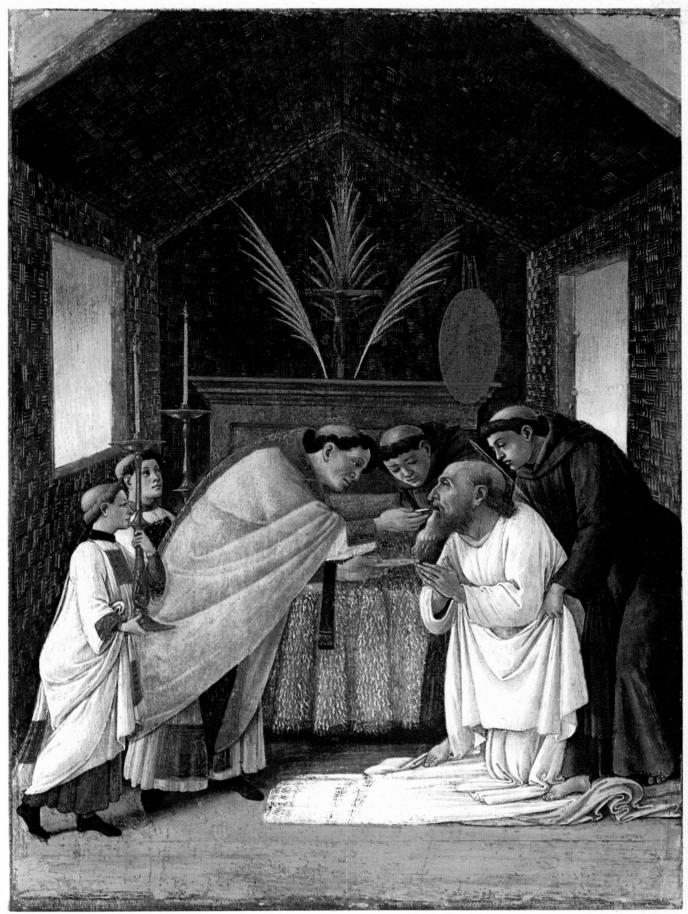

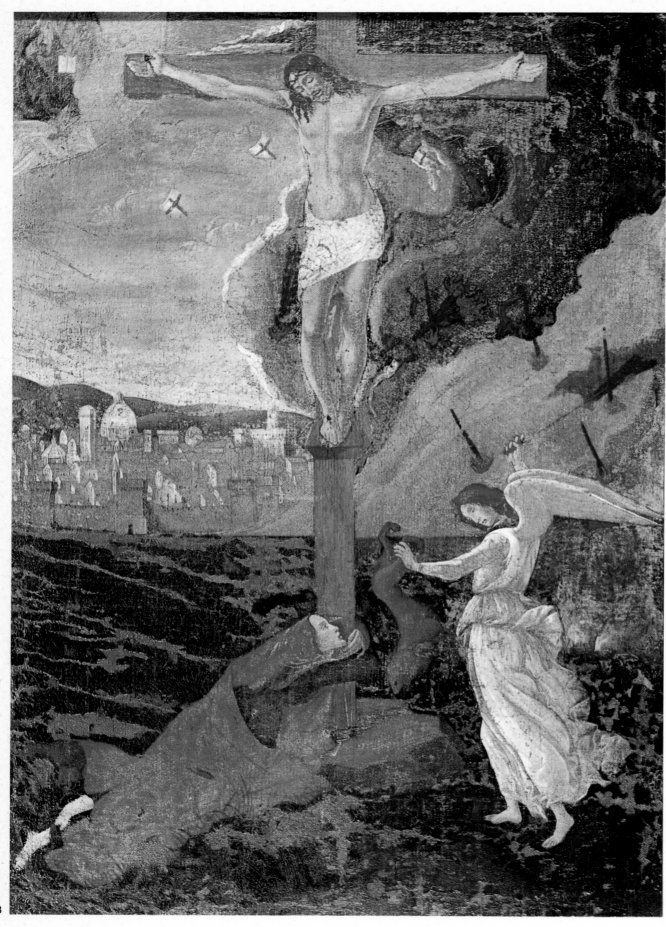

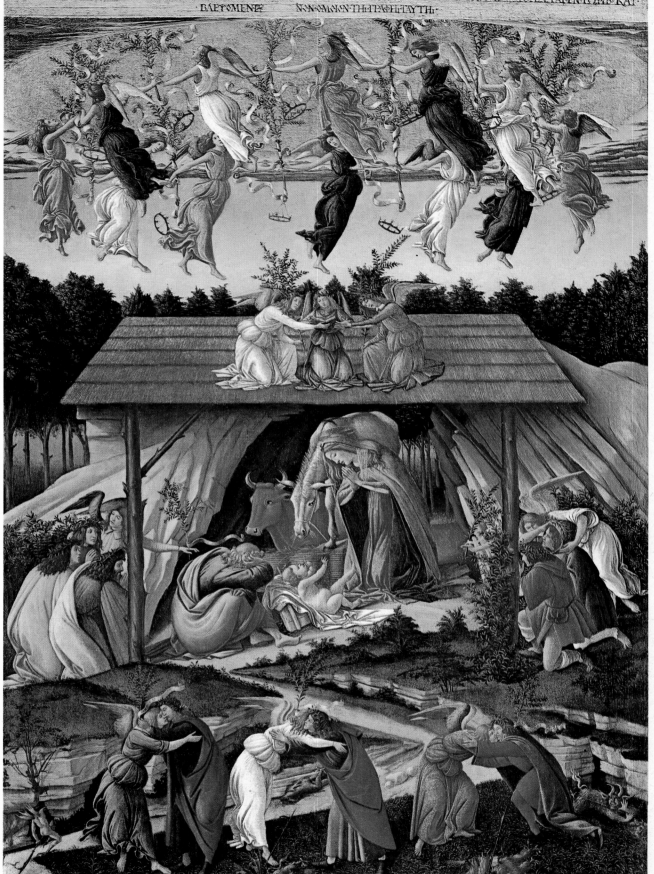

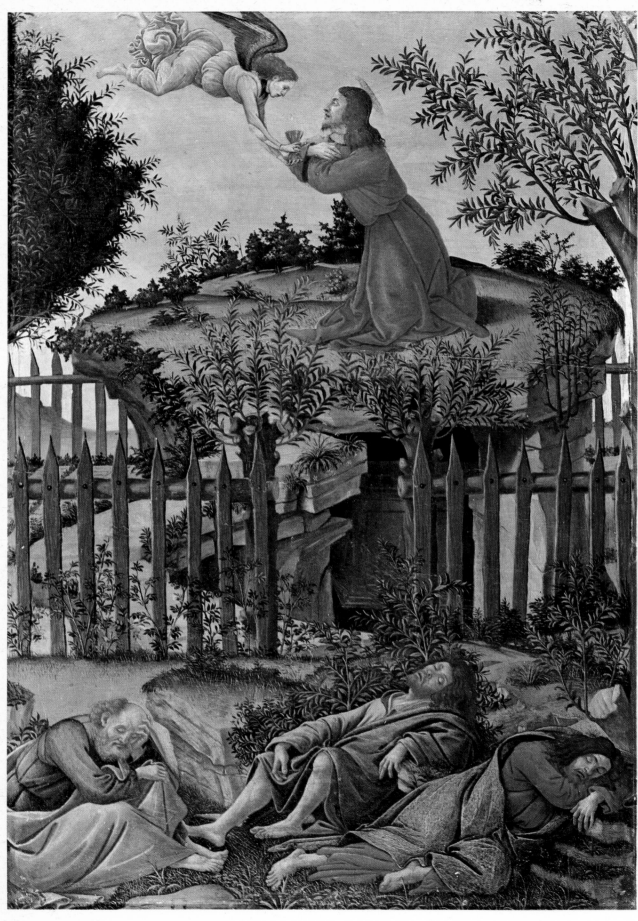